Dress Your Essence

HOW TO FIND YOUR TRUE PERSONAL STYLE
AND EXPRESS YOUR BEAUTY AS A SACRED WORK OF ART

Jennifer Butler

Hardcover ISBN: 978-1-955811-71-2
E-book ISBN: 978-1-955811-72-9
LCCN: 2024911997

First hardcover edition: August 2024

Layout and design: Bryna Haynes
Cover photo: Siddiqi Ray
Editor: Bryna Haynes

Published by WorldChangers Media, PO Box 83, Foster, RI 02825 | worldchangers.media

Praise

"I've had the joy of being both a client and a friend of Jennifer Butler for over twenty years, and I can attribute much of my success, both personally and professionally, to her expert eye. As though gifted with a superpower, Jennifer sees the highest essence of a person's soul as an array of color. Through her encouragement, we begin seeing ourselves as the unique and beautiful beings that we are as well. Most exciting, however, might be that we're finally able to show up in ways that allow others to see and experience us in the fullness of our essence, too! Jennifer Butler is a jewel, and this book is a true work of art."

— **Katherine Woodward Thomas**, *New York Times* **bestselling author of** *Calling in "The One"*

"In my journey as a health and wellness expert, I've learned that balance is key—not just internally, but in how we present ourselves to the world. Jennifer Butler's *Dress Your Essence* is a testament to this balance, teaching us that our external presentation can and should be an extension of our inner selves. After consulting with Jennifer to discover my best colors and styles, I experienced firsthand the transformative power of dressing in alignment with my essence. The impact was profound, not only on my personal brand but on my confidence and authenticity. Jennifer's book is more than a guide; it's a gateway to self-discovery and self-expression. It challenges the conventional approach to fashion, urging us to look inward and dress in a way that truly reflects who we are. *Dress Your Essence* isn't just about creating a memorable impression; it's about honoring our individuality and embracing our unique journey through life. I encourage you to embrace the principles laid out in this book. Showing up as ourselves is crucial for our well-being and is the cornerstone of building a genuine and impactful practice. Let Jennifer guide you through this journey of self-love and empowerment, and watch as your personal and professional life transforms."

— **JJ Virgin**, *New York Times* **bestselling author of** *The Virgin Diet*

"Destined to become a classic in defining authentic beauty, *Dress Your Essence* is a masterful guide to personalizing and expressing one's true style and colors based on Mother Nature's Seasonal harmonies and sacred geometry. As a recipient of Jennifer Butler's brilliance for nearly three decades, I can say with certainty that her work is nothing less than life-changing. As a form of unconditional self-love, reflecting your inner light through your wardrobe has never been so effortless and rewarding!"

— **Ann Louise Gittleman, PhD, CNS, multi-award winning *New York Times* bestselling author of *Radical Longevity***

"*Dress Your Essence* is a wonderful and valuable resource for anyone looking to discover, reflect, and reveal their authentic Self and unique inner beauty through their outward appearance. Let this book guide you on your journey toward joyful self-acceptance and total self-expression."

— **Michael Bernard Beckwith, Founder/CEO of Agape International Spiritual Center, author of *Life Visioning* and *Spiritual Liberation*, host of the *Take Back Your Mind* podcast**

"Jennifer Butler brilliantly reframes personal style as a spiritual art form. If you want to present the most authentic version of yourself, highlight your inherent beauty, and radiate your confidence and charisma, I highly recommend that you keep this book close at hand."

— **Marci Shimoff, #1 *New York Times* bestselling author of *Happy for No Reason***

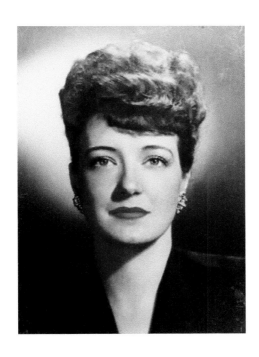

This book is dedicated to the memory of Suzanne Caygill,
the originator of the Color Harmony Theory.

And also to my mom, Maxine Swann Elmberg Butler; the founders and staff at the
University of Santa Monica; and my more than 7,000 individual clients who said YES! to
receiving their unique Color DNA Palette: thank you all for dressing your essence and shin-
ing your individual lights on humanity.

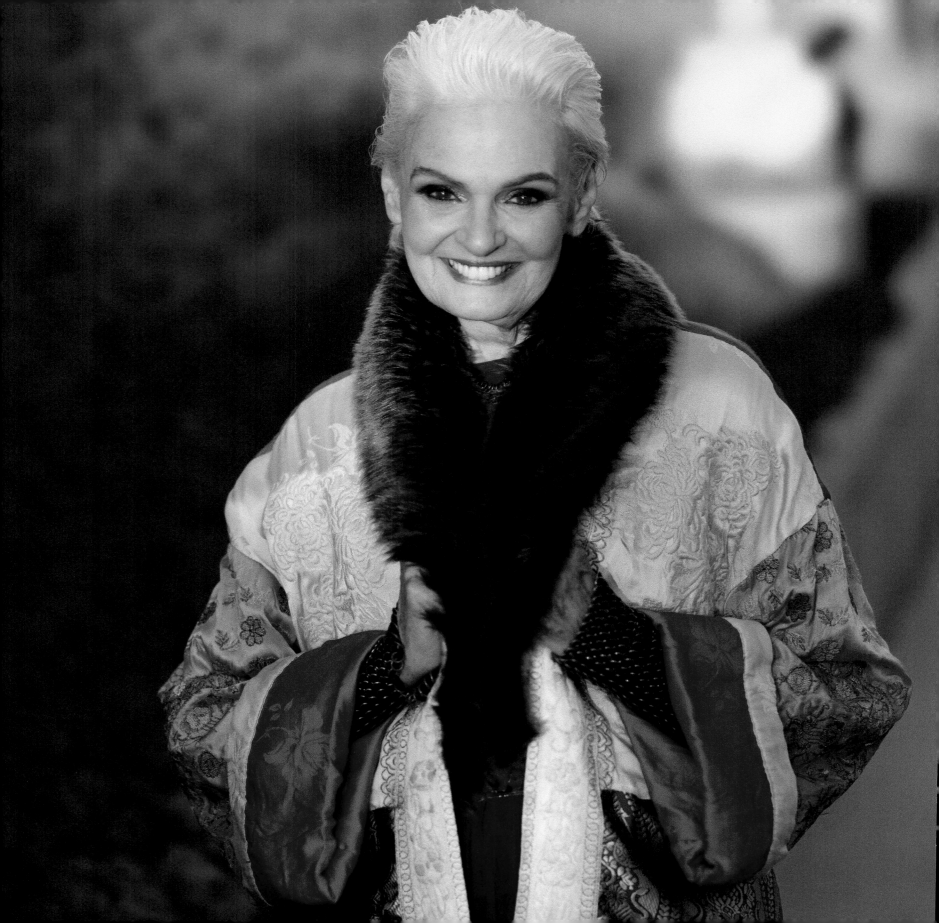

Contents

DR. MARY HULNICK

Foreword

DR. MARY R. HULNICK

I met Jennifer Butler on an auspicious day in 1983, just two years after my husband and I had moved to California to breathe life into a small private school that would grow into an educational institution known throughout the world as the University of Santa Monica, offering Master's degree programs in spiritual psychology. My husband, Ron, and I—both with doctoral degrees in psychology—were the founding faculty. I accepted a role of leadership serving as the executive vice president and Chief Creative Officer. Naturally, given the magnitude of the opportunity we had been given, I was interested in learning how to optimize the ways in which we were presenting ourselves professionally.

I had heard of a master colorist who held salons offering the opportunity to gather and receive individual sessions during which this woman, the originator of color-by-Season work, created a color palette that was uniquely their own. Having always been interested in both inner and outer beauty and having spent hours studying Vogue patterns and choosing beautiful fabrics to sew during my adolescence and adult life, I was intrigued. Even then I had

been aware that some of the clothes I created were truly "lovable" in that the color and style suited me perfectly ... and some weren't.

The day I met Jennifer, who was apprenticing with this master, I was struck by Jennifer's beauty, presence, and how tastefully dressed she was. But it was more than that. Everything from her hairstyle, makeup, dress, shoes, and jewelry reflected her essence. That day, I was told I am a Renaissance Winter—a phrase that resonated deep within my Being. And even then, I was aware that Jennifer, too, was a Winter. I felt an affinity with her, hoping I would get to know her better and learn more about the Winter essence through her example, and even more importantly through her embodiment of her soul essence in the physical world, both through her presentation and way of Being.

After my husband and I received our color palettes, we made an appointment to go shopping with Jennifer. What a delightful experience. Everything we chose and purchased that day was lovable and infinitely wearable and—even more significantly—showcased my husband's

and my essences. These many years later, my palette and tutelage with Jennifer have informed not only my and my husband's wardrobe decisions through the years but also the décor in our home. Our palettes are harmonious and our home reflects both our palettes and our essences, making it a sanctuary for our souls.

A few years ago, Jennifer came to our home and did an extension of my palette. What a joy to witness and experience Jennifer in her element and in her mastery. *Dress Your Essence* is a life-changing book written by an extraordinary woman who sees, understands, and knows how to bring forward the beauty and authenticity inherent in each person through assisting them in recognizing and dressing in harmony with the unique work of art they already are!

I truly believe that reading this book and implementing the information and principles Jennifer shares will not only change how you go about choosing your wardrobe, but will also transform your sense of who you are and your life. What a great blessing for all of us to have an opportunity to participate in Jennifer's extraordinary talent and ability to share her consciousness and work with us!

Through learning and following Jennifer's refined system based on her extensive training as well as her experience through serving thousands of clients during her professional career, you'll have the opportunity to experience transformation in how you see and feel about yourself. That in and of itself is game changing! Imagine no more shopping overwhelm; no self-judgment in fitting rooms; no more buyer's remorse; and no more desire to be invisible!

Instead envision yourself confidently choosing and purchasing clothing in your colors and styles along with accessories that suit you—ones that enhance your appearance and are in harmony with and showcase your very essence. Imagine confidently going to your closet and choosing clothing that illuminates your natural radiance. Further, imagine that your outfits are designed to present you in ways perfect for any occasion—and are an expression of your intentions and your desired outcomes.

Learning to dress in harmony with your own essence can enhance your relationships, amplify your success in your world, and—perhaps most importantly—assist you in experiencing and residing within your Essential Nature, your worthiness as a Divine Being living the miracle of your unique and blessed human experience. Imagine feeling confident, comfortable, and at home in the truth of what you truly are: an emanation of divine love, beauty, wisdom, radiance, aliveness, joy, and grace.

I am forever grateful to Jennifer for sharing her amazing gifts, mastery, and contribution!

Dr. Mary R. Hulnick
Topanga Canyon, April 2024

Mary R. Hulnick is the Executive Vice President and Chief Creative Officer Emeritus, University of Santa Monica; and co-author of Loyalty to Your Soul *and* Remembering the Light Within

Introduction

How many times have you gotten dressed, looked in the mirror, and thought to yourself, "Something is *wrong*"?

Maybe something seemed off about your clothing or the combination of pieces you chose that day. Maybe the outfit you chose just didn't "feel" right. Or, maybe you thought there was something wrong with you—with your body, your shape, or your coloring—and felt a sense of shame or guilt wash over you. Regardless of your thought process, you likely went back into your closet to retrieve another outfit, and another, and another—only to give up in frustration or settle for wearing something that didn't light you up.

The thing is, what we're looking for in our closets isn't clothing. It's *us*. It's who we are. The truth of our being. Our vital essence. And when the clothing we put on our bodies doesn't complement and illuminate that essence, we feel a sense of dissatisfaction, dissonance, or even shame. In response, we try to cover or minimize the parts of ourselves we don't like, instead of highlighting our natural beauty.

This problem is part of a larger social and cultural conditioning. For too long, we have been taught that it is our job to fit the mold that fashion culture sets for us—to buy the clothes on the mannequins and shape ourselves and our bodies to inhabit them. "This looks so good on the hanger," we say. "So why doesn't it look good on me?"

In other words, we've been taught to dress to fit an image we aspire to, instead of dressing our *essence*.

From infancy, we are trained to look outside ourselves to find out who we are within. We learned very early what was lovable and acceptable and what was not, and we learned to adapt how we looked, spoke, and moved through the world in order to feel safe. Many of these strategies involved looking and dressing in a certain way to project an image based on what we desired to receive.

As a result, we may find ourselves deeply embedded in a visual identity that is not ours.

Consider the professional woman who feels that wearing power suits is the way to gain respect, but longs to express the softer side of herself. Or the hard-edged rebel who secretly longs to be included. Or the fashion lover who's been told that "black is chic" but whose hair, skin, and eyes demand a different, more earthy neutral. If our clothing doesn't match what is inside of us, we can become lost under layers of costume. The more incongruent our clothing is with the essence of who

we are, the less visible we become. For some, it's possible to disappear inside a hot pink spandex pantsuit. For others, Spring-like pastels erase the deep, moonlit essence of their natural coloring. It doesn't matter how beautiful the clothes are or how much we love them on other people; if they're not reflecting who we are, they are not right for us.

The fact is, most of us never truly learned to dress ourselves; rather, we learned to dress the image or projection we want others to see when we enter a room. We dress "professional." We dress "intimidating." We dress "cool." We dress "soft."

But do we ever dress "us"?

When it comes to creating a personal style that reflects our true essence, most of us don't even know where to begin. When my clients come to me, they often see their clothing as a problem they want to solve. Maybe they're up for a big promotion or doing lots of public speaking. Sometimes, they're in a life transition like divorce, or are becoming an empty nester. They think, "It's time for my image to get an upgrade." They come to me expecting to be "fixed"—to be taught to cover up their bellies or hide their arms and décolleté so they can be perceived as worthy, powerful, beautiful, or respectable by those around them.

I don't deal in that—because how could I fix something that is perfectly right just as it is?

You are beautifully and uniquely designed to be *you*, and to live life in a way that fully expresses your soul. The shape, coloring, and appearance of your physical body combine to create the perfect vessel for your essence. The ways in which you decorate your body—via your clothing, accessories, makeup, and hairstyle—can either magnify your inner light or conceal it. Dressing to conceal the parts of ourselves we don't like and create an illusion that fits what others have told us is "beautiful" is just another way of devaluing ourselves and keeping ourselves distant from our true power. When we dress to create an idealized image, we say to ourselves and others, "I don't want you to see me as I am, because who I am is not enough."

Embracing our humanity means embracing how we are designed physically. There are no distortions in nature; therefore, there are no distortions in us. We weren't thrown here by mistake. We have an intent to who we are, and the way we're designed physically is part of that intention. Your colors and shape were uniquely designed to bring your essence into physical form; they are the harmony from Mother Nature that has been given to you.

Dressing our essence, therefore, requires a deep understanding of who we are at the core of our being. In order to dress our essence, we must learn to see our soul. We must merge the material and the divine, the physical and the spiritual.

That is the core of my work.

For over forty years, I have been helping people uncover and express who they truly are by identifying their Seasonal essence, revealing their unique personal DNA color palette, and honoring their own sacred geometry. I don't teach my clients to cover their perceived flaws, create illusions with their clothing, follow trends, or dress to impress their clients and peers. Instead, I help them identify the unique palette of colors

and shapes already present in their physical nature and build a wardrobe that mirrors every hue and line.

This work is far beyond "image consulting." It's the retrieval of our core essence and the truth of who we were designed to be—and I'm about to show you how to do this for yourself.

How to Use This Book

This book, at its core, is an invitation to love yourself unconditionally—and dress yourself accordingly.

In this book, I will teach you to dress your essence—to identify the exact palette of colors, textures, and shapes that will bring you into harmony with yourself and make getting dressed a self-honoring experience.

You will learn the ways in which your soul expresses itself through your physical form, including your Seasonal essence, your personal colors, and the sacred geometry of your body. You'll learn how to use texture and complexity to create beauty and harmony. Most of all, you will gain a clear view of who you are, so you can live in, love, and adorn your physical form without feeling like you need to change or conceal any part of yourself.

We will begin in Part I by identifying your "inner light," and what your unique coloring reveals about who you are and how to best express yourself in the world. Then, in Part II, we'll refine our understanding of your perfectly-designed form, and learn to work with the sacred geometry of your face and body. Finally, in Part III, I'll give you the tools to choose the clothing, accessories, and even the home décor that bring your essence to the forefront and allow you to be seen for exactly who you are.

When we ask the right questions, the Universe always has a beautiful answer for us. If, like so many others, you've been searching for true beauty in your closet, I'm here to show you how to recognize it once and for all. What you learn in this book will empower you to become a walking celebration of life—*your* life—and declare yourself as a perfect work of art.

Are you ready to meet yourself, beautiful one?

Then turn the page, and let's begin.

For beautiful eyes, look for the good in others; for beautiful lips, speak only words of kindness; and for poise, walk with the knowledge that you are never alone.

~ **Audrey Hepburn**

Who Is Beauty Actually For?

"Welcome to Bloomingdales. I'm Jennifer. How can I help you today?"

The woman who'd just walked in off Manhattan's 59th Street was peering around the store, taking in all of the mannequins and displays with an expression of mild confusion. Focusing on me, she said, "I'm wondering if you have anyone who can show me what my personal style is?"

I was completely taken aback. No one had ever asked me that question before, and although fashion had been a huge part of my life since childhood, I realized that I had no idea how to answer her.

It was the early 1970s. After graduating from college with a degree in sociology, I decided that I wanted to move to New York City. I had originally applied for a job at *Glamour* magazine, but I didn't get the role, so my parents (who had met at New York University's School of Retailing during the Great Depression), suggested that I look for a job at one of the big department stores while taking evening classes in print design at The New School. Bloomingdales hired me, and I quickly put my talent to work merchandising themed "outposts"

around the store. I excelled at putting together items from different departments to create cohesive outfits for these displays. For example, in the fall when the weather turned, we would have outposts with beautiful winter coats, and also the matching scarves, hats, and gloves that would complete the ensemble.

The Bloomingdales leadership were smart merchants. They were the first to create "lifestyle" vignettes in-store where art merged with visionary living. In addition to the outposts, they also created "signature rooms"—whole scenes composed of perfectly on-trend bedrooms, living rooms, and other scenes from the everyday lives of the fashionably wealthy—and every single item was for sale. Everything in Bloomingdales, and by extension all of my personal work, was focused on helping customers step into the aspirational world of the most popular designers. With enough cash, you could literally buy the dream and make yourself part of it.

Looking back, I can see how I was conditioned to put myself and others in a fashionable box. Women's fashion was evolving; women were entering the workforce in numbers never seen before, and designers were

doing their best to clothe women for success in a male-dominated business landscape. Creating an image became more important than ever for professional women, not least because the feminine ideals of beauty that had shaped the 1950s and early 1960s didn't command respect in the workplace. Triangular shapes, shoulder pads, and masculine cuts were cropping up everywhere. Women weren't thinking about how to dress their unique shapes and coloring to bring out their individual beauty, but rather how to minimize anything about themselves that might be perceived as soft or weak.

Moreover, during this time, there was a big movement toward ready-to-wear collections from the most coveted designers. Where couture had historically been the province of the lavishly rich, now it was available off the rack in standard sizing at a much lower price point. Bloomingdales became one of the top destinations for this new type of fashion. Merchandise was curated with an eye toward helping women craft a narrative with their appearance.

The problem, of course, became that these narratives weren't always each individual woman's story; rather, they were simply making themselves the main character in a designer's fashion fantasy.

The long and short of it was that everything in my career, education, and experience had prepared me to help someone be fashionable and capture the look of the moment. But nothing I'd learned had prepared me to help

someone find their *own* style. Such a thing wasn't even in my consciousness. As a result, the customer's question rocked my world. I could tell her how to dress for a wedding in the Hamptons. I could point her toward the latest bags and shoes that would have all her friends sighing in envy. But I couldn't show her how to look like *her*.

As I walked home that evening, I realized that there was a huge missing piece in my knowledge base. I also had a feeling that, if I wanted to answer the question, "How do I find my personal style," I would have to look outside the fashion industry.

All the beautiful clothes in the world were useless if they didn't make the woman wearing them feel beautiful.

Although I didn't know it at the time, this was the beginning of my quest for essence.

Essence vs. Image

As I shared in the introduction, there is a world of difference between essence and image, but we often get them mixed up.

Essence is our soul made manifest in physical form. It is the union of our energy with our appearance, and it is totally unique to us. It embraces all of who we are, without exception, and reveals our true beauty without needing to downplay, minimize, or hide anything about us. It is entirely pure.

Image, on the other hand, is ego-based. When we work with image, we are attempting to coerce others into seeing us in the ways we want to be seen. Just like I used to do at Bloomingdales, we curate a "look" that conveys an energy or message to others based on their own biases and perceptions, and then squeeze ourselves into it—sometimes literally.

Often, our pursuit of image is an attempt to mask a perceived lack or convey a message. The professional women of the 1970s and 1980s embraced "power dressing" to combat the perception that they were powerless or inconsequential in the workplace. Hippie culture in the 1960s and grunge in the 1990s allowed young people to define themselves in part by wearing the opposite of what

authority figures expected. Women throughout history have relied on "foundation garments" and strategic cuts of clothing to counteract what society has deemed undesirable. How many times have you heard someone say, "Wear black. It's slimming," or, "I can't wear that with my belly/bust/rear"?

More than anything else, dressing to an image helps us cover up our insecurities by *looking like someone else*—someone whom we perceive as more attractive, interesting, powerful, or beautiful than we are. Consider how many women rush to the store to buy a dress after seeing a celebrity wear it, or become obsessed with a certain bag or pair of shoes after seeing it modeled in a fashion magazine.

Aspiration is a powerful driver of consumerism. And, if you think about it, this behavior makes perfect sense. If I feel I am unlovable or "less than" in any way, why would I choose to look like myself? Why wouldn't I choose someone else to look like instead?

Sometimes, dressing to an image can be supportive. Most of the time, though, pursuing image dims our light and makes it harder for us to access the full scope of our own beauty and personal power. Even if the image we are cultivating portrays a portion of our essence, it very rarely captures the full picture.

In Living Color

I was still mulling over the question of "personal style" when I applied for, and landed, a job that had been on my dream list since I was a little girl: a stylist at Vogue

Patterns. I moved to Greenwich Village to be closer to their SoHo location, and immediately felt like I'd gone to heaven.

Part of my job was to plan the fashion shows and choose fabrics to match the season's patterns. Many women still made their own clothing at that time, and Vogue Patterns were the height of sophistication and glamour in the DIY-clothing world. I worked with vendors, magazines, and the best dressmakers in the business, and I couldn't have been happier. I also enrolled in evening classes at the Fashion Institute of Technology (FIT), where I studied pattern-making and draping. This education helped me to understand all the fine points of couture dressmaking, and it still supports my work to this day.

During my tenure with Vogue, we began marketing a product we called "The Hat Box." This was a collection of several garments that, together, created a wardrobe of coordinating outfits. The promotion consisted of a one-woman fashion show that toured around the United States, with each region employing a different model. As a result, several models wore the same series of outfits during the course of the tour. We never changed the garments to fit the models; they were cut to a standard size and the models were expected to fit into them. However, I began to notice that not all of the models looked equally good in the clothing. While some came to life in the garments, others seemed to fade into the wallpaper. How was this possible when the clothing itself never changed?

This dissonance bothered me, although at the time I couldn't articulate clearly what was wrong with what I

was seeing. All I knew was that, even though the models were beautiful women of similar size and height, not all of them looked vibrant in the clothing.

I moved on from Vogue Patterns when my application for an editor position was passed over for another candidate. Instead, I took a job as a promotional stylist with Springs Mills.

While I was there, I received a call asking if I would dress Joan Holmes, head of The Hunger Project, for an important event in New York City. Although I felt completely unprepared for this type of assignment, having only ever dressed fashion models for runway shows, I agreed to take the job.

I met Joan at a 7th Avenue fashion warehouse and immediately noticed that she looked radiant. Her clothes were beautiful, but it was more than that. It was like I could see ... *her*. I was immediately intrigued.

Joan presented me with a fan of fabric swatches. "Here are my colors," she said. "Can you match them, given how little time we have?"

I looked from her face to the swatches and back again. "Oh, my goodness," I exclaimed. "These look just like *you*!"

The swatches were a perfect complement to her skin, hair, and eyes. It was like more of her was coming forward when she was framed by these colors.

Joan explained that she had had her colors done by a woman named Janet Tucker in Northern California. She carried these swatches with her everywhere. "Now," she explained, "I know exactly what colors and shades work on me, and which don't. It makes choosing clothing so easy!"

Immediately after the event, I looked into Janet's two-weekend seminar and made a commitment to travel to California to complete the course within the next three months.

That meeting also precipitated another major development in my career. I was so impressed by Joan's work that I began to dedicate time to serving the Hunger Project, eventually spearheading a fashion show fundraiser where we featured more than $100,000 of high-fashion merchandise—the equivalent of over $800,000 in today's dollars.

My work with Joan also sparked my passionate interest in color and the ways in which color enhances or hides our natural essence. I did indeed attend that workshop with Janet Tucker, and eventually moved to California to work with her and her team. She typed me as a "Winter," one of four Seasonal essences, and I felt like my personal style bloomed as I adapted my wardrobe to a dramatic Winter palette. I loved that color typing allowed me and our clients to find a deeper level of expression through dressing than typical fashion styling could provide. I introduced Janet to my network of New York resources and returned to New York to support her foray into that fashion center.

Even though I had successfully completed all the training Janet provided, there was still something missing for me—some piece of the puzzle that still hadn't clicked into place. I didn't feel quite ready to do this work on my own.

I felt called to return to California, but my Los Angeles-based fiancé, Elliot, and I had called off our engagement, and I was feeling a bit lost and uncertain about the future. Now that we were no longer engaged, I couldn't stay with Elliot. Instead, he dropped me off at the Siddha Yoga Ashram in Santa Monica, a place we'd visited together a few times.

As it turned out, this was a highly fortuitous choice. I embraced life at the ashram, and my two roommates and I soon became fast friends. In fact, a few months into my stay, we were none too pleased to discover that another roommate was to be added to the mix. But, as usual, the Universe was looking out for me.

Our new roommate walked in with a colorful booklet in her hand. "What is that?" I asked.

"Oh, this is my color palette. Suzanne Caygill did it for me. Do you know about the color Seasons?"

I did, of course, because of my work with Janet. I had also heard of Suzanne, although I didn't know until meeting this new roommate that she was the originator of the Seasonal color theory. More, this was the most impressive color palette I had ever seen. It felt ... resonant with my roommate, as though Suzanne had truly captured the essence of her and translated it into colors and light.

Not long after this, there was a big Hollywood event through the ashram. Baba Muktananda was addressing a crowd of nearly one thousand people in Santa Monica. I don't remember the exact words he used, but part of his teaching will always stand out in my memory. He said that each of us in that room was, without question, a true artist—that God is the source of our artistry, and that the true gift we offer as artists is that we allow God to pass through us to create something beautiful. He then asked each of us to consider how we gave of ourselves through our professions.

I had always considered myself artistic, but that day I realized that I was a true artist—an artist of color, form, and fashion. Helping my clients look and feel beautiful was my way of letting God flow through me. Helping them learn about their colors was my way of supporting them to paint their own portrait, every day. And if that was truly my gift, and my artistry, I wanted to learn to do it with as much integrity and care as possible.

I just *had* to study with Suzanne Caygill. I called her immediately after returning home to the ashram and set up an interview.

The day of our meeting, I walked into the Beverly Hills Hotel dressed in a royal blue jacket, an acid green blouse, and a shocking pink cummerbund from India. And then, there she was, wearing a matching peridot pillbox hat, dress, and gloves. To say we were not a visual match would be a huge understatement.

After the interview, she said, "Jennifer, I appreciate your fashion background. However, it does not qualify you to do the work I'm teaching. I work with the essence of the person, not their image. Your background in retailing is a liability. It has trained you to ignore and overwrite the authentic beauty in another person. I cannot in good conscience accept you into my academy."

I was devastated. I wanted to learn from this woman more than anything in the world. But she didn't want to teach me.

I went back to work, but I couldn't get Suzanne's color harmonies out of my consciousness. About six months later, while working at Bullocks as a fashion consultant, I decided to do a "seasonal" fashion show in her honor. I called her to see if she'd be interested in helping me coordinate the show, and to my great surprise, she agreed. This was her chance to introduce her book and teachings to a larger audience.

"Here's my big chance to connect with her," I thought.

The show went well, and I felt like I was able to establish a rapport with her that we hadn't found during our first meeting. Afterwards, Elliot (with whom I was still friends, despite our breakup) suggested that we go together to get our palettes done with Suzanne. I'd already had my palette done ten times by various other "professionals" at that point. All of those palettes were different, and Elliot had been typed as three different Seasons. What did we have to lose?

That session with Suzanne felt like my first experience of being truly seen. She identified me as a Winter, as Janet had previously, with gold as my eye color, bright red as my "romantic" color, and jade green as my Power Color. None of these were colors I had been given before, by anyone. I was enthralled.

As I absorbed my new palette in the subsequent weeks, I thought about how much more "me" I felt. I also thought about all the colors I'd worn in my life: the pink, beige, and taupe that were my mother's essence, and that I took on in tandem with my harmonizing role in my family as an only girl with five brothers. I remembered the orange and brown color schemes of 1970s fashion that I'd worn to fit in at school. I remembered the lime green and hot pink I'd worn to my first interview with Suzanne, intending to demonstrate my knowledge of fashion and color balance. But none of those colors were *mine*.

I'd worn those colors to cultivate a particular image.

I hadn't done it consciously; at the time, I'd had no idea that my clothes were hiding, rather than revealing, the real me. I realized that I had been hiding for a very long time, afraid of intimidating others with my light.

After living with my palette for a few months, I called Suzanne's assistant to see if there was any chance she might reconsider her decision to teach me. Ultimately, Suzanne agreed, and I spent the next year training with her, traveling the country and assisting her with her work. I went on to help her produce three color academies before I made the choice to strike out on my own.

During this time, I also continued my spiritual practice. My longing to expand beyond my current paradigm was insatiable, and this was a period of immense growth for me. I saw the many levels of being, both visual and unseen, that the color work supported. I saw how much people unconsciously revealed about themselves through their clothing choices—how they dressed to a preconceived image, projected their colors onto others, or wore the colors of people close to them in an effort to create a deeper connection. This wasn't just about fashion, or beauty, or even personal power. This was about the soul.

In California in the 1980s, many people were awakening to their desire to meet themselves and discover their true nature. Self-help books topped the bestseller lists, and attendance at personal growth seminars was rising. I saw that I could present my ideas about how we hide or reveal ourselves through our colors at these types of workshops and gatherings. This helped me develop a key part of my individual work: the spiritual and emotional components of dressing. This was the element of the work that had been missing for me for so long, but that I wasn't aware was lacking. I knew that this would be my unique contribution to the beautiful work around color and Seasonal essence begun by Suzanne. By marrying the spiritual, emotional, and physical aspects of beauty and style, I would be able to help people discover who they truly were and how they could reveal that unique essence to the world every day.

This was the art that God wanted to move through me. Through my work, I could now give each person a blueprint of their soul in living color—a vision of their soul made manifest in three dimensions through color, shape, and texture.

That was the beginning of a new chapter in my life—a chapter of the full expression of my purpose, passion, and artistry. What you are about to learn is the culmination of my life's work, and the learning of a lifetime.

Your Essential Beauty

So many clients come to me saying, "I have a closet full of clothes and nothing to wear."

This isn't because they don't own beautiful clothing. Rather, it's because they have a closet full of half-formed images, with no connection to essence. They purchased each individual item hoping that it would make them look and feel a certain way, according to the image they desired to project at the time. But, as we know, such images rarely represent a person's essence, therefore, the article of clothing (and its associated image) that was alluring in the store no longer feels authentic or complete. Dressing from that energy can feel like trying

to force together puzzle pieces that don't quite fit. The end result is disjointed, incomplete, and often quite uncomfortable.

I'm here to tell you, it doesn't have to be this way! After years of searching, I have finally found what I believe to be the perfect answer to the question posed so long ago by the random woman in Bloomingdales.

How do you discover your personal style? You dress to match your essence.

Imagine opening your closet and knowing that you can, with minimal effort, create the perfect ensemble to wow a prospective employer, command a big stage, express empathy with a grieving friend, or spark more romance with your significant other. Imagine no longer needing to try on three or five or ten outfits before settling for one that only sort of works. Imagine knowing exactly how to select and layer your clothing and accessories in order to flatter your unique features, body shape, and personality.

All of this becomes possible when you learn to dress your essence.

As we learned in the introduction, the art of dressing your essence is the art of seeing yourself as a whole and complete being, a divine masterwork. Your colors, Seasonal essence, sacred geometry, and personal textures form a complete representational picture of who you are, just as layers of paint and individual brushstrokes combine to form a masterful portrait. There is nothing about you that needs to be changed, improved, fixed, or eradicated for your soul's essence to be allowed to shine

through. In fact, the more you try to do those things, the more suffocated and diluted your essence will become.

Most of all, dressing your essence is about cultivating self-love. Not the faddish, shallow version of self-love that we see on Instagram memes, but real, deep, unconditional love that comes from knowing the truth of who you are. I've witnessed women and men of all ages, backgrounds, and life experiences come into this state of true self-love and self-acceptance by wearing and being seen by others in their colors. We all have the capacity and necessary tools to cultivate self-acceptance in a loving way. It's time to reveal our truest selves, and to fully appreciate the gifts we bring to the world and the ways in which God wants to move through each of us to create a more beautiful, loving world for all.

As part of the process of learning to dress your essence, you will need to identify where you have been attempting to use image (and the clothing and accessories that support it) to minimize, cover, or manipulate your essence. Where has the perfect masterwork of you been painted over, dulled down, or left to languish in the shadows? Where can you shine a light to allow yourself to be fully seen?

The process of this covering up of our true selves begins, as does so much else, in childhood. In the next chapter, we'll look at where you have been conditioned to cover, minimize, or deny your essence. Then, I'll show you how to begin to undo that programming to recognize the true colors and sacred geometry that create the living work of art that is *you*.

Reflecting the Soul

When I was about six years old, I was standing in the front yard of our Hibbing, Minnesota home, which my mother had designed. The sun was shining brightly as we stood on the lawn, admiring her achievement. The house itself was a weathered pink brick, cozy and inviting; the front door was a lovely sage green. Jaunty pink azaleas had been planted on either side of the walkway.

And there, standing in front of this pretty picture, smiling joyfully, was my mother.

"Mommy, you are so beautiful!" I gushed.

"It's what's on the inside that counts," she replied, ruffling my dark hair. And, of course, it was true—both for the house and for her.

Years later, while working with Suzanne and her color systems, I remembered that day, and I had a revelation. My mother was beautiful always, but she was *more* beautiful in front of that house—beautiful enough to have emblazoned that memory in my six-year-old mind. Why did I remember that one moment so clearly? Because the house was a representation of her!

The brick was a deeper value of her skin tone. The sage green of the front door was her eye color. The pink azaleas in the yard were her romantic tone. When she stood in front of our family home, with her unique human palette reflected in its design, I could see her *essence*.

We are not born in our parents' image, but we are trained to reflect that light. When we truly see our parents' essence as children, we long to be part of it, so we can (consciously or unconsciously) model ourselves after it.

I certainly did this with my mother. I was my mother's only daughter, surrounded in the family lineup by five boys. I became the peacekeeper, deeply invested in preventing (or at least mitigating) the daily fights that erupted between my brothers. I learned to speak softly, keep my opinions to myself, and go along to get along. I wore my mother's soft Spring pinks and gauzy greens, and followed in her footsteps in all ways. I wanted to fit in, not stand out. I recall many moments of hopelessness, feeling like the person I naturally was—pensive, sensitive, observant, decisive, and most of all, female— was not the person who naturally belonged as part of

my family dynamic. I sometimes wished I was more of a tomboy, because involving myself in games and sports would allow me to better connect with my brothers, but that was not at all my inclination.

Instead, I funneled my deep feelings into my creative pursuits—in particular, sewing. By a young age I could already sew very well, and by the time I was ten could complete the majority of any sewing project without help from my mother. This activity nurtured my self-esteem and allowed me to admit that being female might not be such a disadvantage after all. In fact, making myself beautiful through the art of fashion was a way for me to feel powerful.

Things got shaken up a bit when I was twelve. My mother was a big proponent of education, and she was determined that all six of her children would graduate from college. This was practically unheard of in the 1960s, when fewer than 10 percent of high school graduates went on to college. However, there was a very big obstacle to her plan: my dad's salary would never stretch to cover six college tuitions.

So, my mother took a risk and opened a fabric store.

I didn't realize at the time how very brave this was. In those days, respectable mothers did not go out to work. In fact, I was mortified to tell my friends that my mother was starting a business, because, in their eyes, it might make my dad look like he wasn't providing well enough.

My mom's response? "We're all in this together. This is how I can do my part."

Little did I know that the seeds of my own path were sown the moment she opened the doors to her shop, The Calico Cat.

My mother was known for stocking unusual fabrics that helped people make beautiful clothes for themselves. After some hesitation, I began to assist her at the store. My gift for sewing was incredibly helpful when assisting customers, and I quickly shifted from withdrawn, solitary child to fashion-forward, self-expressive young woman. Soon, I realized that I loved the work I was doing at Mom's store and that the acknowledgment I received from the community outweighed my fear of being visible. There was something magical about helping women both my own age and much older than myself show up powerfully in their lives.

The Calico Cat was soon a thriving landmark in our town, and Mom and I set out to produce a string of fashion shows. Somehow, Mom convinced the people at Vogue Patterns to send us a trunk of the latest designs from New York. I loved the streamlined, silhouetted styles that were all the rage in the early 1960s; they fit my aesthetic much more comfortably than the full skirts and cinched waists of the 1950s. As we sewed garment after garment for our exhibitions, I watched the beautiful illustrations come to life before my eyes. I also got to be both a model and the commentator for our shows, which helped me get more comfortable on stage.

In the fall of 1964, I was (I thought) a very mature and worldly senior in high school, and it was time for me to decide which college I would attend. My vision of academia mostly involved dreary libraries and laboratories, and study programs in the fields of law, science, and history. I wasn't at all sure this path was for me, but eventually I selected Wilson College in Chambersburg,

Pennsylvania, where I would study sociology and art history.

My true dream was to work with Vogue Patterns in New York City, but my parents were not thrilled with the idea of me attending college in a large city. Wilson College was close enough to the city to please me, and just far enough away that my parents knew I'd be safe. On certain weekends, I'd ride the train into New York and meet my mom for fabric shopping excursions on Madison Avenue.

At my women's college, *everyone* was into fashion. Everyone borrowed each other's clothes. I had many beautiful outfits that I'd sewn myself, in a variety of gorgeous fabrics from around the world, and in my quiet way became a popular trendsetter. I even opened a boutique on campus called Piece of Mind to raise money for our student union. This quickly escalated to a full-scale store where I sold fabrics imported from India, and my fellow students sold their artworks and other handmade goods.

Then, the summer before my senior year, I took part in an exchange program called The Experiment in International Living, which allowed me to travel to India to stay with a local family. This not only broadened my cultural and theological horizons, giving me a glimpse into a spiritual orientation completely opposite in many ways to my own, but also expanded my fashion horizons. India at that time was quite undeveloped, and most people existed in a level of poverty we in the United States could scarcely imagine. Most people I met owned only one or two items of clothing. However, this didn't deter them from exploring fashion; in fact,

it seemed to inspire them to choose the fabrics, cuts, and patterns that most beautifully represented their essence. Even with a lack of available resources, there was a commitment to beauty and authenticity.

When I returned to school, I brought with me not only what I had learned from the women I'd met in India, but also a trunk full of beautiful silks and other fabrics from the markets there.

Not long after, I was nominated to participate in the Top 10 College Girls contest, sponsored by *Glamour* magazine. 1969 was the first year in which nominees' eligibility was not based solely on their looks, but also on their talents, abilities, and contributions. Apparently, my little campus boutique was the first of its kind, and was extraordinary to the judging panel. That, combined with the beautiful clothing I'd made for my entry shoot using fabrics from India—a vest from a mirrored pillow, a gold silk shirt with a big collar and full sleeves, crepe bell-bottom pants, and a formal outfit made from a gorgeous Indian bedspread—apparently inclined the decision-makers in my favor. I was selected as one of *Glamour*'s 1969 Top Ten College Girls in the nation.

The contest winners were flown to New York for the magazine photo sessions, and then to Italy for a fabulous vacation experience. I was thrilled to have been recognized for something that flowed from me so naturally. However, my enthusiasm waned when I saw the results of the photo shoot.

As a Winter woman, my palette is vibrant, rich, and bold. However, the *Glamour* editors dressed me in a shaggy taupe coat for our photos. Instead of standing out, I faded into the background, just another pretty girl on a page of

pretty girls. I was there, but you couldn't see me. *I* couldn't see me. At the time I didn't know why I sensed this, only that something was wrong, and I was disappointed that something as miraculous and exciting as this contest had produced a final product that was so ... bland.

After college, I moved to New York and began my career at Bloomingdale's. During this time, I began to move away from my Indian-influenced designs and started following the trends of the ready-to-wear scene. I was featured in *Women's Wear Daily* after being spotted on the street in New York in a midi skirt I'd designed. Designers were scouring the globe for inspiration—Russian furs, ethnic shawls and scarves, Japanese kimonos and silks. Yves Saint Laurent went to Morocco and came back full of inspiration. Denim also came into greater prominence at that time, and couture jeans were all the rage. It was exciting to be part of the scene.

But I had no personal compass. I'd started by imitating my mother's style; now, I was following the style of fashion influencers. Retail became a lifestyle experience. I was buying everything that was popular, and I knew how to put together great outfits, but I had lost myself. I was looking for the answer in all the wrong places, buying things I never wore because they "didn't feel quite right." I was the woman with a closet full of nothing to wear—right up until I discovered the art of Seasonal color typing and learned how to dress my essence.

This "taking on" of others' essences is very common. I can't tell you how often I find a husband's colors in his wife's closet, and vice versa. And, if we aren't wearing our partner's colors, we are often wearing the colors of our other family members, close friends, or colleagues! These choices often tie into behavioral trends or modes of relating to dress that prevent us from finding our unique beauty and style.

What's Your Fashion Attitude?

Each of us has inherited and acquired feelings about beauty and dress. These cumulative beliefs, habits, and tendencies combine to create what I call "fashion attitudes," or ways of relating to our image. Often, we gain these attitudes from our parents, or in response to our parents. Sometimes, they come from our interactions with our culture, society, or the world at large. And, like any acquired set of beliefs or attitudes, they have served and protected us in some way in the past.

For me, standing in my bold, rich Winter essence was challenging because I spent so long as a quiet shadow beside my mother and brothers. I'd also let my own aesthetic lapse as I moved further into the fast-changing world of designer fashion. I acquired what I now call a "sublimated attitude" toward fashion, meaning that my desire to look as I believed others wished or expected me to look buried my natural inclinations with regard to shape, texture, and color. If I followed the pack, I reasoned, I wouldn't stand out—at least, not quite as starkly. I would be accepted and invited into the fashion community.

I'm sure the connection between this attitude and my childhood experiences is not lost on you. However, it took many years for me to fully see and understand it.

To the right, I've listed the twelve most common fashion attitudes and how they manifest. Chances are, you'll recognize yourself in at least one of them, if not more. This is important information to know in our quest to reveal your essence.

Please understand that there is nothing "wrong" or "bad" about having one or more of these attitudes. They are simply patterns that you can choose to adopt—or not adopt—as you see fit. Sometimes it can be painful to realize that we are playing out inherited or acquired attitudes that no longer serve us, but in order to learn to dress our essence, we need to make an honest inventory of our relationship to beauty and where that relationship comes from. Often, our ideas about beauty don't even belong to us, but are inherited from those around us or the fashion industry at large. Gaining awareness in this area will empower you to make any needed shifts in your relationship to your own beauty and yourself as a living work of art.

The Twelve Fashion Attitudes

1. The Resigned One

2. The Unemotional One

3. The Dutiful One

4. The Rebel

5. The Last in Line

6. The Modest One

7. The Conformist

8. The Invisible One

9. The Armored One

10. The Sublimated One

11. The Status Quo Adherent

12. The Forever Teen

After reading the descriptions on the next page, which of the twelve attitudes ring true for you? Are these attitudes still serving you? If you were free from all expectations, social demands, and personal fears, what would you do differently in terms of beauty, fashion, and style?

The Twelve Fashion Attitudes

1
The Resigned One

The Resigned One is a person who has given up trying to make themselves beautiful or find a style that works for them. They often wear the same few articles of clothing repeatedly, and their color choices consist mostly of black, possibly with some bland denim or white shirts thrown in.

2
The Unemotional One

This person has found a mechanical means of dressing based on a formula from a so-called expert. They find little to no satisfaction from beauty and fashion, and instead follow a set of rules that may or may not do anything to assist them in expressing their essence. The Unemotional One tends not to have an emotional or joyous relationship to clothing and style; rather, they seek to minimize daily choices around getting dressed or to systemize dress.

3
The Dutiful One

The Dutiful One is someone who wears a uniform, and seldom to never ventures away from that mode of dress. (This can also extend to someone who does their hair and makeup the same way every single day.) They have never had the experience of beauty as an outlet for creative expression; as such, dressing is a mundane chore for them. This attitude can also apply to those who actually wear a uniform at work and lack the energy or ambition to dress their essence outside of their job.

7
The Conformist

This attitude describes someone who dresses according to what is acceptable within their immediate family or social group and will not explore beyond this margin. This might be cowboy boots for the woman who grew up in a family of ranchers, or "preppy" polos, khaki pants, and boat shoes for the man whose family spent summers on a sailboat. The Conformist never rocks the boat or dresses in a true expression of their essence, either because they are afraid of being singled out in the social group or because they were never exposed to other modes of beauty.

8
The Invisible One

This attitude is all about concealment and self-protection. This person will often wear clothing that envelops them and cloaks their true shape. This is often seen in oversized or "tent" dressing when someone is overweight, and in girls who develop ahead of their peers. This attitude is a means of keeping oneself safe and distant from others, in particular to avoid unwanted attention or sexual objectification. This is different from the attitude of The Modest One in that it stems from a personal desire to conceal the body rather than a familial, religious, or social mandate.

9
The Armored One

This person will often be seen in clothing that fits too tightly, as if their clothing is holding them together. Tight pants, vests, corsets, stiff jackets, and wide belts are often components of an Armored person's wardrobe. They will often feel that if they are not wearing rigid clothes they will fall apart. This is another attitude that is about keeping oneself safe from others.

4
The Rebel

The Rebel is the opposite of The Dutiful One, and often embraces trends that are perceived as "shocking" or "unattractive." Think of the flappers of the Roaring Twenties, the spiked hair and leather of the Punk movement, or the ripped plaids and combat boots of the Grunge era. There is always a strong emotional element to rebellious dressing, a backlash against how some authority told this person they "should" or "could" dress. However, while rebellious styles can feel powerful and compelling, they can easily overpower a person's essence.

5
The Last in Line

This is an attitude shared by those who make sure everyone in their immediate family or social structure is dressed to look their best, but who deny this for themselves. This may result from a feeling of "not measuring up" or believing that their children and/or spouse are more important than they are. This attitude is often accompanied by a "martyr" mentality in which the person perceives themselves as sacrificing their joy or self-expression for the good of others.

6
The Modest One

This is an attitude that involves physically hiding or shrouding one's essence in order to remain unseen. This particular stance can result from exposure to strict, culturally mandated moral or religious codes, or from a feeling that one's body should be hidden because it is evil, shameful, or provoking to others. In this attitude, what is valued is invisibility, meekness, and minimization of one's presence, as opposed to full self-expression.

10
The Sublimated One

This attitude is common among those who lack a sense of self-worth. Often, they will dress according to the dictates of designers and magazine spreads. Their wardrobe is often disjointed and full of random patterns and color schemes, reflecting the shifting trends. Although they usually love fashion as an art form, they rarely dress in a manner that allows their true essence to shine.

11
The Status Quo Adherent

The Status Quo Adherent is someone who is aware of their potential to attract attention if they show up in full expression, and therefore chooses to "tone it down." They're afraid that if they express themselves fully that they will look odd or "weird," or make other faux pas. Where The Conformist is unaware that other styles exist or doesn't yet have a relationship with these other styles, The Status Quo Adherent dresses as expected for the occasion at hand. They are afraid to risk a strong visual statement, and therefore dress to blend in rather than stand out.

12
The Forever Teen

Also known as "glory days dressing," this style applies to those who have difficulty letting go of their high school or college days and the clothing associated with those times. Men are often seen in shorts, team jerseys, and baseball caps in situations when other modes of dress would be more suitable and flattering. Women may wear "cutesy" styles meant for younger girls and teens, or may continue to dress as they did while in a sorority or at college. No matter how this attitude manifests, it is usually tied to a lack of emotional growth and an inability to move on from the past.

Cultural and Societal Perceptions

In addition to our personal views and attitudes about beauty and fashion, we also carry numerous societal and cultural imprints around what looks good and what doesn't. Often, these ideas will clash with who we truly are, or where we are in life.

Take, for example, the pervasive "youth culture" in the United States, particularly for women. Once a woman reaches a certain age, she essentially becomes invisible—to the media, in the office, and even in social settings. Youth is closely tied to beauty. If natural aging renders a person unworthy of notice or regard, is it any wonder that some women develop the fashion attitude of The Forever Teen, The Dutiful One, or The Last in Line?

Social media has turned up the volume on new trends. "Influencers" talk about what they love, but their personal preferences are just that: personal. However, we might feel compelled to "have what they're having," even though it has nothing to do with us.

In 2024 a plain T-shirt will sell for a few dollars, but the same shirt with a designer logo might be $600 or more. This is great if the logo enhances your own beauty, but a huge expense if you disappear behind it.

As of the publication of this book, it has become trendy for very young people to dye their hair gray. More than once, a young woman has approached me on the street to ask how I got my hair to be this color. My secret: I cropped it close to my head and let nature take over!

The moral of the story, of course, is to "do you"—and only you—regardless of what is popular. Treat social media as an "idea factory," not a how-to guide.

Learning to Perceive

Perception, in this context, is our ability to clearly see the true nature—the essence—of ourselves and others. Your clothing and how you present yourself is a direct reflection of your relationship with yourself as a living work of art. Your clothes reveal not who you are, but who you *think* you are.

In order to pierce the veil of manufactured beauty and the mythos of the fashion industry, we must learn to uplevel our perception. This will empower you to truly see and connect with your own essence and that of others.

There are three levels of perception regarding beauty and fashion. Like the fashion attitudes we explored earlier, these levels of perception will determine how you relate to your self-expression through image, and also how you attempt to manage others' impressions of you.

Which of these levels of perception resonates most for you?

LEVEL 1
Image-Based Dressing

At this level of perception, your initial response to your appearance is often based in attraction, projection, and judgment. You want to be bigger or smaller. You want to be bright and sassy, or elegant and commanding. You may have specific ideas about what you like, but this doesn't always translate into what looks best on you. For many, this level of perception is about fitting in with or rebelling against expected standards.

If you are at this level, you may have a lot of outfits that you love in theory but aren't comfortable wearing. You may buy things on a whim because they looked great on the mannequin or on the website. You're attracted to certain styles and colors, but you can't really say why, and you haven't thought about it consciously.

Most of all, when you are dressing an image rather than your essence, you will always feel like you're falling short when you get dressed. Deep down, you know there is more you could be experiencing, but you don't know what it is or how to find it.

LEVEL 2
Strategy-Based Dressing

This approach to dressing is highly cerebral and is designed to enhance others' perceptions of you. Perhaps you have noticed the impact of your clothing choices and have begun to incorporate "purposeful" dressing to convey a certain energy, attitude, or status. You're dressing for an edge and for the win.

Strategic dressing can take many forms. Perhaps you read somewhere that red is a "power color," and so you choose a bright red dress or tie for your next speaking engagement. Perhaps you own a business and have adopted a "Dutiful" attitude of dress in which you only wear clothing branded to your company. Maybe you want to play a power game at work, and so you opt for stark black suits and white shirts. These choices may be based on popular perception and even scientific research, but they may not ring true to who you are. You might be "dressing for success" but ending up with cookie-cutter fashions that don't actually display your uniqueness and strength.

At this level, you're still concerned with outside opinions and how others view you, so it feels natural to adopt clothing choices that might produce the results you desire.

LEVEL 3
Essence-Based Dressing

At Level Three, you have actually begun to perceive your true essence, and therefore see dressing as an extension of your creativity, personality, and inner light. You trust your colors and your clothing choices. You know how it feels to dress in concert with your inner truth and are no longer overwhelmed by the myriad of choices that the fashion world offers. You may ask, "Is my real self coming through in this outfit?" or, "Is the focus on my clothes, or on me?"

At this level of perception, you are looking beyond the surface. When you shop, you look for vibrational matches to your essence, not images that you want to portray. You know what works and what doesn't simply by how you feel when you put it on. You know that the right clothes will feed and nourish your natural vitality rather than sapping or diminishing it.

Dressing at this level also inspires deeper connections with others. You know that your purpose for dressing beautifully and creatively is to reveal a deeper part of yourself that you want others to know. As a result, you become an instrument for a greater magic to occur.

Living in Full Expression

These days, I treat getting dressed as a spiritual and creative experience. My presentation is an extension of my soul. By the time you are done reading this book and putting the instructions into practice, I believe it will be the same for you.

The fact that certain fashion attitudes and perceptions have been part of your journey so far does not mean that they are serving you well, or that you need to continue to adhere to them. You always have a choice to move toward the fullest expression of your essence. The first step is to commit to seeing the "real you." Notice if your clothes are masking or revealing you.

Next, note what shifts are needed. The goal is to align your attitudes, beliefs, and expectations to the "real you," releasing everything that does not serve you.

Once I became aware of my family influences, my near obsession with fashion, and the fashion attitudes that were moving me far off course from authentic self-expression, it was clear that a course correction was needed. Using affirmations has helped me greatly in my own journey from living as The Sublimated One to being in full expression of my essence. When we tell ourselves something over and over, we will begin to see it as truth. Therefore, saying positive, loving, and essence-affirming things to ourselves each day will have a cumulative positive effect on our self-image and self-esteem.

I have used these ten principles for years in my own life, and I have taught them to more than seven thousand clients. Read them each time you get dressed, and watch your relationship to your wardrobe transform.

My Ten Principles for Dressing Your Essence

1. I am a unique expression of God's creation on this planet.

2. When I let go of my negative illusions about myself, I am free to embrace my natural self.

3. I am an extension of Mother Nature and therefore an integral part of the Universe.

4. I am perfect just the way I am. I do not need to change myself in any way.

5. Authentic, radiant beauty is within me and cannot be defined by someone or something outside of me.

6. My clothes and accessories are an extension of my inner radiance.

7. I can dress myself in a way that is inspiring to others.

8. I can wear colors that enliven me and therefore enliven all life on the planet.

9. I am a walking celebration every day because of the clothing and colors I wear.

10. When my outer expression matches my inner expression, I show up powerfully, beautifully, and authentically.

To shine your brightest light
is to be who you truly are.

~ Roy T. Bennett

Revealing Your Inner Light

When Jana was younger, she felt like she was always battling herself.

She was a joyful, exuberant young child, but circumstances in her family forced her to take on a lot of responsibility early in life. Joyfulness wasn't a strength in those times—in fact, it didn't feel safe for her to be joyful in the face of all the weight she was carrying for her siblings. She became serious and withdrawn, reserving her joy for her private moments when no one else could see it. She felt disconnected from others and unsure of how to "be" in the world without putting her vulnerable heart at risk.

When she came to me, she had pegged herself as a Winter Seasonal essence, like me. Her "outsider" feelings and her ability to see the bigger picture seemed to fit the Winter profile. She dressed mostly in black and white with some silver or bronze accents, and generally came across to others as confident but self-contained.

However, when I did Jana's color analysis, I immediately saw that she was a Spring. The triad of her hair, skin, and eye colors told the story of her Spring Seasonal essence and provided a beautiful frame for her inner sunlight. In unguarded moments, her warm nature and inner joy came bubbling up. As she became more comfortable with me, her vivacious nature emerged. She had spent most of her life as a leader both in family and business, but her natural energy was that of a cheerleader, initiator, and guide.

"Your joy is your strength," I told her. "It's time to stop hiding it away."

Jana's palette is that of a Blooming Spring, full of deep teal, peacock blue, bright iris, and ruby red. Sophisticated but not muted, her colors highlight her essence, allowing others to see her true nature and supporting her to step into greater visibility and joy in her everyday life.

Spring, Summer, Autumn, Winter

Dressing our essence begins with identifying our Season—the unique "filter" through which our inner light is made manifest in the world.

Most of us are looking for a place where we feel safe enough to fully express our true self on Planet Earth. We all want to feel connected to ourselves and the Universe/Source. However, because there is so much focus around image and idealized beauty, we feel more and more alienated.

Although my relationship with the Seasonal essences and palettes began from my focus on style and image, my own personal growth has led me to see the true nature of this work. It is important to integrate the physical, mental, emotional, and spiritual aspects of ourselves in order to become whole and complete.

Many of us can recognize aspects of ourselves in each Seasonal essence at different times and in different ways. However, every one of us is born with a specific blueprint for who we are in this lifetime. This is our Seasonal Essence—the template the Universe gave us in order to live our purpose in this life, and the key to our ultimate fulfillment and joy

Each Seasonal type is associated with particular energies and segments of the natural life cycle. Together, the four Seasons make up the natural cycle of creation.

Spring

Spring's inner light is sunlight. Spring energy is that of beginnings, the planting of seeds, and the inner child.

Fun and playful, Springs seek to initiate and develop change, awareness, and relationships.

Summer

Summer's inner light is twilight. Summer energy is sustaining; it is the divine feminine, gracious, and compassionate.

Summers nurture what has been planted. They see nuanced details, and allow all of us to live in a state of grace.

Autumn

Autumn's inner light is firelight. Decisive and authoritative, Autumn is the abundance of the harvest, and the reaping of what has been sown.

Autumns embody the divine masculine, strong and purposeful. They are results-oriented and natural leaders.

Winter

Winter's inner light is moonlight. Winter energy is that of the fertile void, and the spirit which is eternal.

Highly spiritual, Winters are discerning. They have the ability to see the big picture and hold extremes within a higher vision.

When we understand the truth of our most natural selves through our Seasonal type, we can also understand the truths of others with more compassion. We can learn to contrast without needing to compare. When we discover who we are, and allow our essence to be seen, we can also give that grace to others.

Later in this chapter, I will share a Seasonal typing quiz to help you identify your Seasonal essence and work with it throughout the rest of this book. However, there are a few things that are necessary to discuss before we undertake that discovery—in particular, how our upbringing and conditioning can influence our experience of our own energy and dim our natural light.

Temperament vs. Essence

Beyond our Seasonal Archetype, we also must deal with the personality we've created. Essence is the truth of who we are—the beauty in the artwork that is us. Temperament (aka personality) is how we have adapted to the world for survival.

For example, my mother, a Spring, was always the life of the party, and she wanted the same for me. When she invited twenty kids to my birthday party, she thought she was honoring me. As a Winter, what I really wanted was to have a beautiful time with my two closest friends—but I learned to adopt a Spring temperament to please my mother and harmonize our differences.

Sara, a Summer, took on many commanding Autumn tendencies due to her academic drive and desire to be taken seriously. Someone had to be in charge, so why not her? Now, she is slowly learning to access her sophisticated but fluid Summer nature, which she had suppressed because it felt out of sync with her ambitions.

How we behave in the world when we're wearing our public face or "on-stage persona" is often very different from who we are in private. And, often, the behaviors we gravitate toward are less than successful for us, because they are not, in the end, authentic. While being able to assume the qualities of a Spring was helpful for me early on in terms of sales and business, in the end, it kept me from being able to reveal and share the insights and spiritual depth of my Winter nature.

What's Your Essence?

The following quiz will help you discover your unique Seasonal essence.

Read the questions below and mark your answers on this page or on a separate sheet of paper. Remember, it's important to answer these questions as the version of you who is most authentic—the "you" who you are when no one is watching—rather than the image you wish to present to the world.

Also, please try to distinguish between what you like and are attracted to, versus what is *you* in mind, spirit, and soul. There is also often a difference between what is true for us and what we are attracted to. Often, we seek the qualities of the Seasonal energy that we believe we lack, or that correspond to the image we are trying to project to the world. (More on this later.) Therefore, we are often attracted to our Seasonal opposite. If you answer the quiz questions according to what attracts you or who you want to be, you are unlikely to discover your "real self." If you are uncertain, go with the answer that feels closest to the truth.

I recommend taking this test alone. However, if after tallying your answers you end up with a split between two Seasonal essences, it can be helpful to have a good friend take the quiz with you and offer honest feedback. Sometimes, those who love us can see us more clearly than we can see ourselves.

Are you ready? Let's begin.

Discover Your Seasonal Essence

1 ARE YOU AN EXTROVERT OR AN INTROVERT?

a. Extrovert: I am outgoing and am the life of the party

b. Introvert: I am shy and quiet by nature

c. Extrovert: I am outgoing and very candid and frank

d. Introvert: I prefer to observe from a distance

2 YOU AND YOUR FRIEND ARE HAVING A FIGHT. YOU'RE FRUSTRATED BECAUSE …

a. They're making things more complicated than they need to be

b. They doesn't understand why you feel the way you do

c. They won't get to the bottom line regarding what's going on

d. They are not being definitive and are vacillating

3 WHEN YOU'RE NOT AT YOUR BEST, YOU ARE LIKELY TO BE …

a. Fickle

b. Lazy

c. Bossy

d. Depressed

4 WHICH OF THESE ADJECTIVES DESCRIBES YOU BEST?

a. Curious

b. Nurturing

c. Responsible

d. Confident

5 WHICH JOB SOUNDS MOST APPEALING TO YOU?

a. Public relations/ performer

b. Teacher/engineer

c. Entrepreneur/ adventurer

d. Diplomat/president

6 YOU MOST OFTEN MAKE DECISIONS BASED ON …

a. How you feel in the moment

b. Data I've gathered and past experience

c. Looking clearly at the facts

d. Your intuition

7 PEOPLE LIKE TO HANG OUT WITH YOU BECAUSE YOU …

a. Are entertaining and fun to be with

b. Are calm and sensitive

c. Are always willing to try new things

d. See infinite possibilities

8 WHAT ARE YOUR MOODS LIKE?

a. I keep things light and don't dwell on negative things

b. I have deep emotions and I am private about them

c. I can be impatient and hot-tempered

d. I tend to keep my emotions contained so it appears I've got it all together

9 WHAT ARE/WERE YOU MOST LIKE AT SCHOOL?

a. I am easily distracted, especially by the social side of school

b. It takes me a while to process information, but I like lots of sources and research

c. I do well, but I get bored by having to remember lots of details

d. I am organized and I like solving problems

10 WHEN IT COMES TO ROMANCE, YOU ARE LOOKING FOR …

a. Someone who really likes your playful side and is fun to be with

b. Someone who will romance you and enjoys the courtship

c. Someone who can take charge and isn't threatened by my strength

d. Someone you can really communicate and connect with on a deep level

11 WHICH OF THE FOLLOWING BEST DESCRIBES YOU?

a. I'm afraid of not being taken seriously by others

b. I'm afraid of being too vulnerable or too soft

c. I'm afraid I'll scare people if I exert my full power

d. I'm afraid my intensity distances people from me

12 I RESPOND MOST DEEPLY TO WORK BY THE FOLLOWING ARTISTS:

a. Chagall, Warhol, Monet

b. Renoir, Degas, Constable, Ansel Adams

c. Rembrandt, Da Vinci, Rodin, Missoni

d. Velasquez, Dali, Matisse, Escher

13 I FEEL BEST IN CLOTHING DESIGNED BY …

a. Versace, Chanel, Tommy Hilfiger

b. Calvin Klein, Armani

c. Fendi, Missoni, Gucci

d. Donna Karan, Vera Wang

14 I WOULD DESCRIBE MY PERSONAL ENERGY AS …

a. Funky, charming, irreverent

b. Romantic, refined, flowing

c. Fiery, rugged, majestic

d. Formal, elegant, reflective

15 WHEN I WALK, PEOPLE MIGHT SAY I …

a. Bounce with a light step

b. Have a slow, languid pace

c. March with strong, purposeful steps

d. Glide across the room

16 I MOST ENJOY MUSIC BY:

a. Lady GaGa, Mozart, Gwen Stefani, Justin Timberlake

b. Pachabel, Sade, James Taylor, Barbra Streisand

c. Tchaikovsky, The Gypsy Kings, U2, Tina Turner

d. Yanni, Beethoven, Joan Baez, Prince

17 IF I WERE LIGHT ENERGY, MY FRIENDS WOULD CATEGORIZE ME AS …

a. Sunlight b. Twilight c. Firelight d. Moonlight

18 IF I WERE TO EMBODY AN ARCHETYPAL PERSONALITY, I'D SEE MYSELF AS …

a. The Coquette/Flirt or the Rogue/Rascal b. The Princess/Lady or the Gentleman c. The Lioness/ Huntress or the Rugged Man/ Musketeer d. The Moon Goddess/ Priestess or the Hero/Magnate

19 IF I WERE AN ANIMAL, I WOULD BE …

a. Kangaroo, Golden Retriever b. Persian Cat, Dove c. Lion, Grizzly Bear d. Eagle, Zebra

20 IF I HAD TO DESCRIBE MY PERSONALITY, IT WOULD BE …

a. Instantly relatable b. Thoughtful and supportive c. Grounded and productive d. Reflective and meditative

21 AT A WORLD PEACE SUMMIT, MY CONTRIBUTION WOULD BE …

a. Seeing the bright side of things b. Asking thoughtful questions in a systematic manner c. Leadership and my ability to produce results d. Decisiveness and a broader perspective

22 I BELIEVE THE WORLD NEEDS MORE …

a. Joy b. Security c. Abundance d. Insight

23 WHEN I DRESS, I PREFER TO FEEL:

a. Crisp and light b. Soft and flowing c. Textured with movement d. Dramatic and silhouetted

24 IF I WERE A BUNCH OF FLOWERS, I'D BE …

a. Daisies or daffodils b. Burgundy roses or wisteria c. Chrysanthemums or lush ferns d. Calla lilies or orchids

25 A LOCATION THAT BEST EMBODIES MY WAY OF BEING WOULD BE …

a. Disneyland, Provence b. England, a southern manor home c. Italy, Africa d. New York City, Spain

26 MY FRIENDS WOULD DESCRIBE MY OVERALL PERSONALITY AS …

a. Fresh, buoyant, living in the moment

b. Thoughtful, methodical, flowing

c. Results-oriented, loves a good challenge

d. Reserved, visionary, decisive, strong

27 AT MY MOST ATTRACTIVE, I FEEL …

a. Radiant, enchanting/ dapper

b. Elegant, pretty/ gentlemanly

c. Magnetic, ravishing/ ruggedly handsome

d. Striking, exquisite/ gallant, heroic

28 I PREFER TO WEAR …

a. Faded denim and cheerful prints

b. A soft shirt with slacks, a softly-draped scarf

c. Animal prints, textured fabrics, safari, camouflage

d. Black and white ensembles, formal attire

29 MY FAVORITE DINING EXPERIENCE IS …

a. Picnics, finger food, checkered tablecloths

b. English tea, ladyfingers, soufflés

c. Feasts of plenty, lasagna, pasta, barbecue, buffets

d. Sterling and crystal, fine champagne, white linen

30 I'D NEVER BE CAUGHT WEARING CLOTHING THAT IS …

a. Too formal or overly coordinated

b. Constricting, stiff, or heavy

c. Fussy or overly frilly

d. Old, worn out, or cheap-looking

31 IF I WERE ONE OF THESE WOMEN OR MEN, I WOULD BE …

a. Jennifer Garner
Kate Hudson
Brad Pitt
Will Smith

b. Grace Kelly
Barbra Streisand
John Lennon
Ralph Fiennes

c. Julia Roberts
Eva Mendes
Hugh Jackman
Denzel Washington

d. Jackie O.
Catherine Zeta Jones
George Clooney
Barack Obama

32 PEOPLE OFTEN PERCEIVE ME AS …

a. Charming and vibrant

b. Compassionate and nurturing

c. Resilient and independent

d. Elegant and refined

33 DEEP DOWN I SECRETLY DESIRE …

a. To be respected and valued

b. Just one person who really understands me

c. For someone else to lead the charge

d. For someone to appreciate me

SEASONAL ESSENCE QUIZ

34 AS A CHILD, I ENJOYED ...

a. Hide and seek, jacks, tether ball, hopscotch, team sports, sailing, flying

b. Dress up, make believe, tea parties, taking things apart to see how they worked, reading

c. Playing in the mud or climbing trees, exploring outdoors, building forts, rugby, football

d. Paper dolls, dressing up, deep imaginative play, marching to the beat of my own drum

35 WORDS I USE TO DESCRIBE THINGS I LIKE INCLUDE ...

a. Awesome, fun, cool, brilliant

b. Beautiful, delicious, sensual, artistic

c. Impressive, important, valuable

d. Masterful, unique, top-quality, perfect

36 FINALLY, WITH REGARD TO THIS QUIZ, I FOUND ...

a. It was too long

b. I vacillated between two or more answers. I really had to think about it

c. Lots of answers applied to me, so I selected the best ones

d. The answers were obvious. There were no gray areas for me

Analyze Your Results

Now, it's time to tally your answers. How many "a" answers did you choose? How many "b," "c," and "d" answers? Add up the number of answers corresponding to each letter.

Congratulations! You have taken your first step toward discovering your Seasonal essence!

If you have nearly-equal numbers in two Seasons, read the upcoming sections carefully 'and choose which Season seems most closely correlated to your true essence—not what you are attracted to or wish you were.

NOTE: this quiz is a starting point, a compass to guide you toward your unique essence. It is by no means scientific and is not a substitute for a consultation with a professional color expert.

Answer Key

MOSTLY A'S: SPRING

MOSTLY B'S: SUMMER

MOSTLY C'S: AUTUMN

MOSTLY D'S: WINTER

Now that you have identified your Seasonal essence (or your two most likely Seasonal essences), it's time to dive in and explore the world of color. In this next section, you will be introduced to the neutrals and colors that support each of the Seasonal essences.

SPRING

spring

Spring

Buoyant · Blooming · Charming · Enchanting · Endearing · Enthusiastic · Funky
Humorous · Lighthearted · Romantic · Shimmering · Uplifting · Vibrant

Spring is sunlight energy, playful and uplifting. In the life cycle model, Spring is creation and renewal, the emergence of new life. As a Spring, you inspire and motivate others, uplifting them to live from a different place within themselves. You are often at the leading edge of new endeavors, helping things get off the ground and providing the "spark" of creation to ignite momentum.

Your gift is lightheartedness; your carefree nature helps others find joy. Others see you as a cheerleader, an optimist, and a "people person."

Spring may be attracted to Winter's dramatic contrast (including bright colors and/or black and white dressing) because of their desire to be taken seriously and may take on the more aloof and reflective qualities of Winter. However, this is not their natural state and may lead to feelings of disconnection and separation from others.

SPRING ARCHETYPES

Women: The Inner Child, the Coquette, the Angel, Aphrodite

Men: The Rogue, the Rascal, the Troubadour

SPRING'S GIFTS

Lightheartedness, renewal, rejuvenation, playfulness, inspiration, creativity, compassion, living in the moment

SPRING'S CHALLENGE

Feeling that others do not take you seriously, which may result in you presenting yourself as other than the lovely, effervescent person you are. Your work is to nurture your inner depth so you can attune to the profundity of life and not just its frivolities.

IDEAL ROLES FOR SPRING

Public speaking, sales, motivation, personal training, coaching, teaching, entertainment, human relations, public relations. In short, anything related to inspiring, guiding, or influencing the public.

The Spring State of Being

"What can I do to uplift and inspire myself and others today? Where and how can I infuse joy?"

Spring Style Don'ts

For women: dark, heavy, or muted colors; shockingly bright colors; black and white dressing; anything that feels matronly, "vanilla," or overly formal.

For men: heavy or stiff suits; black-and-white dressing; muted or overly dark colors; anything that feels staid or boring.

J.J.'s Spring Glow

Muted, washed-out colors made gregarious J.J. fade into the background. A bright coral dress and animated accessories bring her to life!

Spring Style Dos

Spring's style is fresh, crisp, carefree, flirtatious, playful, and funky/unique but not overly loud.

For women: denim, "athleisure," mix-and-match patterns, polka dots, pinstripes, animated prints, fun jackets, and statement shoes.

For men: lightweight suits, printed pocket squares, bow ties, florals, Hawaiian shirts, playful shoes.

SUMMER
summer

Summer

Charming · Compassionate · Deliberative · Feminine · Flowing · Graceful
Refined · Reflective · Sensitive · Tenderhearted · Tranquil

Summer is twilight energy, sensual and contemplative. Summer occupies the "sustaining" phase of the life cycle—neither beginnings nor endings—and understands the process of living and sustaining life.

As a Summer, you are thoughtful, quiet, tender, and gracious. You love order and "appropriateness" and bring a sense of calm and balance to your work and relationships. You may be interested in history and the charm and poise of bygone times.

Your gift is beauty. You have an eye for detail in all things and are at your best when relating one-to-one with others. Others see you as thorough and detail-oriented but also intuitive. You are a great listener, and people often come to you with their challenges.

Summers may be attracted to Autumn's authoritative and commanding energy, as well as Autumn's fiery colors, because they want to be seen as strong and capable. However, this is not their natural state, and may lead to burnout, fear, anxiety or other mental illnesses, and lack of work-life balance.

SUMMER ARCHETYPES

Women: The Lady, the Princess, the Gracious Hostess, Hestia

Men: The Prince, the Gentleman, the Lord of the Manor

SUMMER'S GIFTS

Softness, fluidity, deep listening, vulnerability, service, nurturing, understanding complexity and nuance, seeing the "shades of gray."

SUMMER'S CHALLENGE

To live in flow and nurture your vulnerability while living in a world that often equates power with force. Although you may feel pressured to produce immediate results, your strength lies in your ability to process the complex.

IDEAL ROLES FOR SUMMER

Researcher, engineer, therapist, counselor, healer, educator, project manager, mediator, or any role that highlights developing processes and systems, providing support, or detailed work.

The Summer State of Being

"What can I do to help myself and others experience more grace today?"

Summer Style Don'ts

For women: overly-bright or high-contrast colors; heavy or tailored fabrics; busy, loud prints; overly casual clothing; stiff shoulders; heavy shoes; "preppy" or athleisure styles.

For men: heavy or stiff suits; rugged or too-textured fabrics; "preppy" or athleisure styles; "biker" or too-rugged styles.

Sophie's Essence

Sophie's jeans and bright stripes were too casual for her elegant, soft beauty. Summer hues and refined fabrics bring her twilight essence to the forefront.

Summer Style Dos

Summer's style is based on the S-curve. It is flowing, unstructured, and moves with the body.

For women: focus on the feminine with chiffon scarves, flowing skirts and pants, sheer layers, thoughtful/subtle details, lace, embroidery, flowing ruffles and ribbons, romantic jewelry, period pieces, feminine silhouettes.

For men: softly-structured blazers and pants, poet shirts, muted ties, sweater vests, cashmere, refined textiles.

AUTMN autumn

Autumn

Complex · Deep · Earnest · Fiery · Independent · Majestic
Regal · Resilient · Rugged · Strong · Warm · Wise

Autumn is firelight energy. In the life-cycle model, Autumn is the harvest—the completion and fruition of all that has been seeded. As an autumn, you are warm, earthy, independent, abundant, and complex. You love grandeur, theater, and being in charge. Your strengths are to lead, produce, and complete.

Autumn is a masculine energy. You exude dynamic power, and are straightforward, grounded, and focused. You're always asking, "What's the bottom line?" and hate wasting time on needless details. You are a natural leader and passionate about what you believe in. You value freedom, big tasks, and big tests, and you never do anything halfway.

As an Autumn, you may be attracted to Summer's softness and feminine energy, as well as Summer's muted and romantic colors, because you may not feel completely comfortable taking charge and assuming responsibility. However, this is not your natural state, and may lead to frustration with others who don't operate with the same level of energy and self-sufficiency.

AUTUMN ARCHETYPES

Women: The Huntress, the Lioness, Athena, Diana, the Earth Mother

Men: The Hunter, the Lion, the King, the Adventurer

AUTUMN'S GIFTS

Leadership, management, getting the job done, producing tangible results, manifestation, straightforward communication

AUTUMN'S CHALLENGE

To lead with warmth rather than dominance, and to bring out the best in others instead of trying to do it all yourself—or, conversely, to embrace your natural leadership and take charge instead of playing small to make others comfortable. To become interdependent as well as independent.

IDEAL ROLES FOR AUTUMN

CEO, CFO, leader, people manager, executive assistant, director/producer, fundraiser, project manager, activist, change agent, builder, educator, influencer, athlete, anything to do with nature and the outdoors.

The Autumn State of Being

"How can I support myself and others to complete their assignments and produce results today?"

Autumn Style Don'ts

For women: plain, smooth, overly frilly or overly delicate; muted pastels; too many bland basics.

For men: clothing without texture; simple or plain shirts and ties.

Lynn's Fire

Lynn's pale colors washed out and dulled her fiery Autumn essence. Rich earth tones bring out her powerful glow.

Autumn Style Dos

Autumn's style is complex, full of texture and movement. It can run from outdoorsy to full-on glamour.

For women: complex designs, animal prints, safari, camouflage, suede, tweed, leather, statement jewelry and accessories, substantial fabrics and textures that create movement.

For men: rustic tweeds, suede, leather, corduroy, fisherman's sweaters, elaborate ties, substantial fabrics and textures.

winter

Winter

Discerning · Dynamic · Elegant · Focused · Formal · Luxurious · Mystical
Powerful · Refined · Stark · Still · Structured · Unique

Winter is moonlight—mystical, cool, and refined. In the life-cycle model, Winter is the energy of reflection, the still and quiet time before Spring's renewal. As a Winter, you see things from an elevated perspective. You are a solitary observer, and are intensely committed to your principles and ideals. You love simplicity, artistry, elegance, and unusual things, and you never settle for less than the best.

You possess the ability to see things from a distance and articulate the highest and best outcomes for the situation at hand. When you get excited about something, you bring an element of dynamism and clarity. Your brand of leadership is visionary, future-oriented, and perfectionistic within its scope.

As a Winter, you may be attracted to Spring's playful and outgoing nature, as well as Spring's vibrant and exciting colors. You may have even trained yourself to be outgoing on the surface while remaining removed from others. However, this is not your natural state, and trying to fit in with others instead of deeply relating will render your gifts less effective.

WINTER ARCHETYPES

Women: the High Priestess, the Queen, the Heroine/Villainess duality

Men: the Hierophant, the Hero/Villain duality

WINTER'S GIFTS

Visionary leadership, discernment, the ability to hold extremes, meditation, living in the silence of life, mastery of a chosen path, refinement, luxurious living

WINTER'S CHALLENGE

To come back to Earth instead of operating at a distance. To build deep and meaningful relationships with others.

IDEAL ROLES FOR WINTER

Visionary leader, administration, design, architecture, producer, talent manager, art director, high-end sales, spiritual leader/teacher, marketing, anything involving quality presentation, luxury goods, or the creation of luxury experiences and events.

The Winter State of Being

"Where can I enhance my own and others' experiences with my perspective today?"

Winter Style Don'ts

For women: flowing, flowery, or unstructured pieces; subtle or muted colors; informal clothing.

For men: subdued or muted colors; draped suits and pants; rustic or too-textured fabrics.

Christopher's Presence

Christopher's jeans and loose shirt were much too dull for this Winter Hero. Elegant fabrics and a stronger silhouette create a more dramatic look that honors his Winter essence.

Winter Style Dos

Winter's style is silhouetted, contrasting, angular, and based on the undulating line. Black is the most important neutral for Winters.

For women: dramatic, clearly-defined silhouettes; architectural prints, abstract design, statement jewelry, shoes, and accessories; lots of red, black, and white; metallics; luxurious, formal fabrics.

For men: tailored suits; clean lines, deep colors; geometric and abstract tie designs; formal cuts.

I see your true colors.
That's why I love you.

~ Cindy Lauper

Your True Colors

My client Kate used to dread sales meetings. A recognized and respected expert and consultant in her field, she was almost always a top-three contender for corporate projects, but was having trouble closing sales.

"I would get through the selection rounds with ease, and then we'd have that final sales call. It would go wonderfully. I'd demonstrate that my company was the best vendor to solve the problem at hand, and it would seem like everyone on the team was in agreement. But then, the final selection for the job would come in— and I would lose the contract."

When Kate came to me, she was discouraged and struggling. "I just can't seem to close the biggest deals," she told me, "and I don't understand why! I've looked at all the professional factors, and it just doesn't add up."

One thing in particular about Kate's story stood out to me. She said that potential clients always prefaced their communication about denying her the contract in the same way: "After much deliberation, we decided to go with [competitor]. We knew you would understand."

When we looked at her colors, we found that Kate was a Summer Seasonal essence, and many of the pieces in her wardrobe complemented her unique color palette ... but in all the wrong places. In particular, her favorite suit—a double breasted wool skirt and jacket— was in a lovely eggplant, her Support Color. However, Support Colors convey empathy, reliability, cooperation, and second position, not authority. By wearing her Support Color for her final sales presentation, she was basically telling potential clients, "I'm here as a friend and support system, not as a leader." No wonder clients thought she'd understand when they passed her over!

When we completed her palette, we identified Kate's Power Color as a deep, rich blue. When she started wearing this instead of her eggplant for final meetings, she started closing clients with ease. Her Seasonal palette allows the parts of her essence that are aligned with her expertise to shine through in a way that can be perceived by others.

Kate still tells me that her investment with me was the best career decision she ever made. "I could not be as successful as I've become without this knowledge."

The only way we are seen by others is through our pigment. If I learned to paint you—your skin tone, hair color, and the beautiful matrix of your eye color—you would recognize yourself in that work, and others would recognize you as well. If someone paints you with the colors that are true to the reality of "you," you will recognize yourself without distortion.

When we duplicate any aspect of our physical coloring in our wardrobe, we highlight that aspect of ourselves rather than resisting or hiding it. For example, Kate was comfortable communicating her loving, caring, supportive self to clients, so she unconsciously chose a color that mirrored that energy. She created an "image" that spoke to a supporting, empathic resource. Because the eggplant of her favorite suit was in fact a less powerful, more supportive color, her clients saw this supportive aspect of her as authentic—hence their transparency when they turned her down for consulting roles. Had she been wearing colors not her own, she would have been perceived as forced or inauthentic. Kate's Power Color highlighted a similarly authentic aspect of her essence, but in a way that others could perceive as authoritative and worthy of respect. Thus, the part of her most suited to her role as a consultant was brought to the fore.

The constellation of your colors brings you into physical form.

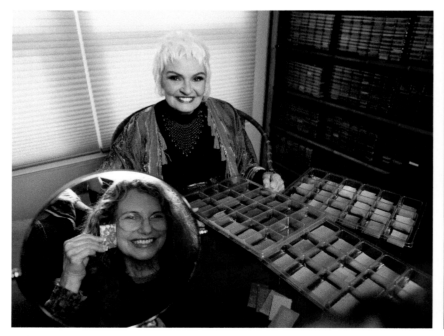

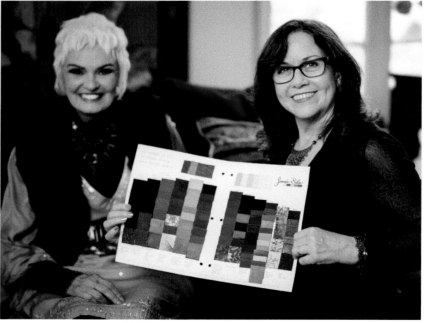

JENNIFER CREATING UNIQUE SEASONAL ESSENCE PALETTES FOR CLIENTS

Seasonal Color Basics

Everyone's palette is unique. However, there are some basic Seasonal color guidelines that apply that will help you narrow down your colors.

These guidelines are based on the color wheel, pictured at right. Every color has its "complement," which is directly opposite on the color wheel. Analogous colors are next to each other on the wheel. Triads are based on the primary and secondary colors: red/yellow/blue and orange/green/violet. (See diagrams below.)

In this chapter, I will also reference "color value." This refers to the lightness or depth of a particular color. So, if we are looking for "a darker value of your eye color," that means a deeper or more intense shade of your eye color.

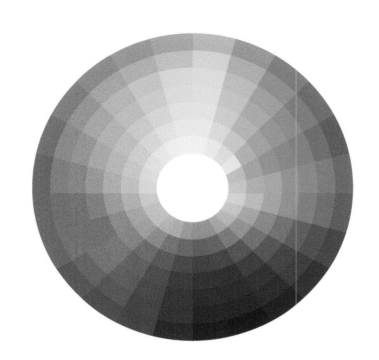

COLOR COMBO 1	COLOR COMBO 2	COLOR COMBO 3
Complementary Colors	Analogous Colors	Triadic Colors

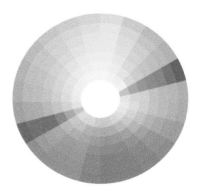 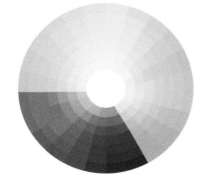 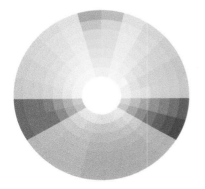

Spring: Triadic Colors

As mentioned on the previous page, the triads on the color wheel are red/yellow/blue and orange/green/violet. Springs do well wearing elements of a triad in their outfits. For example, a spring could wear a green dress with a cognac brown (orange undertone) boot and belt, bronze jewelry, and a patterned scarf with green and purple elements. Or they could wear red pants with a blue-and-white polka dot shirt and gold jewelry (yellow undertone). The contrast provided by color triads keeps things fun and fresh, matching the Spring energy and dynamism.

Avoid: dark, muted, or heavy colors; monochromatic dressing; too much black.

Summer: Analogous Colors

Unlike the Spring palette, the Summer palette works with analogous colors, meaning colors that are next to one another on the color wheel. All colors for a Summer essence will come from the "cooler" side of the palette and are generally muted and sophisticated. Teal, forest, deep blue, navy, grape, eggplant, violet, and burgundy are core colors of the Summer profile. Note: Some Summers have a warmer eye color like brass, olive, or antique gold. These warmer-eyed Summers can successfully wear warm and cool colors together, i.e., olive with purple.

Avoid: warm tones like true green, yellow, orange, and bright red; overly bright clear colors or bright metallics.

Winter: Black, White, Metallics, and Saturated Jewel Tones

Black, white, and charcoal gray are the ideal foundation for a Winter palette. Metallics bring the reflective qualities of Winter to the wardrobe. Reds range from cardinal red to magenta, blues from royal blue to peacock, and royal purple—all on the cooler side. Earth tones can also be part of the Winter palette when they reflect the eye color; for example, copper, olive, antique brass, or mustard.

Avoid: warm "Autumn" tones like rust, amber, avocado, and orange; drab or muted colors.

Autumn: Warm, Bold Earth Tones

The Autumn palette is also analogous, but on the warm side of the color wheel. It is full of warm, rustic colors. Rich rust, bronze, and brown; animal prints; greens ranging from olive to hunter green and camouflage; burnished metallics like bronze, brass, copper, and antique gold; mustard yellow; warm orange and umber; and deep emerald are all good starting points for the Autumn essence. Denim should always be dark rather than light blue or stonewashed.

Avoid: black and white dressing; cool tones like blue, violet, pink, and burgundy.

You may notice that many of the items in your closet that feel most "like you" correspond to the guidelines for your Seasonal essence. Remember that you are not trying to create an image. Instead, you are looking to bring the truest parts of you to the forefront. By wearing your true colors, you are honoring yourself, Mother Nature, your soul, and your higher power. There is only one of you on the planet. It is your responsibility to bring your light forward in the way only you can.

Now that you know where to begin with your Seasonal palette, let's get a little more technical.

Finding Your Unique Colors

When you're living from your soul essence, you're choosing colors that not only match you but uplift you— the colors that support your life force and your radiant inner energy. We begin to find those colors by looking at your face—in particular, your hair, skin, and eyes.

Color is energy. Each color vibrates at a frequency of light. Our response to color is subjective, both physically and mentally. We see color, but it is more than just sensory input; color makes us feel.

No two people are alike. You, as a human being, are a prismatic collection of colors that are entirely unique to you. Your palette, therefore, will be as individual as your fingerprint. Moreover, it is a bridge between your inner and outer self. By choosing the colors that authentically represent your physical body, you reveal your inner essence.

This exploration is also where things get "real" for most people in a spiritual sense. By committing to discovering your own unique palette, you are also committing to seeing yourself as you are—not as you wish you were, not as you want to be seen, and not as the image you've manufactured. It is therefore vital to request that your inner critic take a day off—or, better yet, a permanent vacation—and approach this next portion of the work with an open heart and a curious mind. Get excited about studying the truth of you. You are a beautiful work of art, and identifying the triad of your hair, skin, and eyes will help you bring forth the true beauty that is your natural design and essence.

In order to find the colors that most closely express your essence, we need to become both artist and scientist. Artist, because we are looking for how the color illuminates, uplifts, and captures our essential energy. Scientist, because we need to fully examine the colors of our hair, skin, and eyes, determine their respective values, and reveal our color harmonies from there.

As we go into the science and art of your colors, please keep in mind that what is presented here is a starting point rather than the whole journey. You will always get the best palette when you work with a certified color expert/stylist.

EYE COLOR

Although you may think that your eyes are a single color, they are in fact made up of a multitude of beautiful shades. For example, your "brown" eyes might contain bronze, brass, copper, olive, amber, or even violet. Blue eyes might contain bits of green, turquoise, gold, silver, platinum, gray, or violet. I call these prismatic colors the "lights" of your eyes.

To determine the "lights" of your eyes, go outside into natural light. Then, hold up a hand mirror so you can see the light hitting your eyes. Or, take a picture of your irises with your phone or have a friend do it with a camera. Get as close as you can, so you can capture the way the sunlight illuminates the prisms of your eyes. What main color do you see?

If you can't quite identify the color you're observing, try holding up swatches, fabric, or items from your closet next to your eyes. You may find that putting a blue scarf next to your "blue" eyes actually makes them look more teal or green! When you hold up a color that truly matches the lights of your eyes, there will be a sense of resonance and "rightness" that you cannot deny. So, don't operate on assumptions. Take the time to truly observe yourself and marvel at the nuance of your natural coloring.

Your eyes will also reveal ideal colors for your jewelry and metallics. Do you see silver or pure, bright gold in your irises? Or are the tones more bronze, brass, or copper?

Look at the whites of your eyes as well. That color will give you the whites, ivories, and/or light grays of your palette—your palest neutral tones.

Notice how blue eyes may also include gray tones. In this case blue is the primary eye color and gray becomes a wardrobe basic or neutral. Blue eyes are enhanced by silver or pewter jewelry.

If your eyes are green or hazel, pine green might be your primary eye color, and olive green might become a wardrobe basic or neutral. Green eyes are most often enhanced by antique brass or pewter jewelry.

Once you have identified your eye color, consider what you've learned. How is this color represented in your current wardrobe?

HAIR COLOR

It's important to note that when we reference hair color, we are talking about your natural hair color as it is right now, today. Many people, particularly women, have been coloring their hair for so long that they are unsure what their natural color looks like. If this is you, look instead at your eyebrows. Or, grow out your hair color for two to three months and study the color at your roots.

If you are a Spring or a Summer, your hair color will determine not only some of your "neutral" shades but also the level of contrast you should bring to your outfits (more on this in Chapter 6). For example, someone with very blond hair will likely have values of beige or sand in their palette to match their hair, whereas someone with medium brown hair will have values of chocolate, chestnut, or saddle brown. For Springs, Summers, and Autumns, it is recommended that you incorporate shoes and accessories in your hair color. This will "ground" or anchor any outfit.

Most Winters have either black or very light hair. If you are a Winter and your hair has gray accents, you will match your hair with charcoal gray clothes, accessories, and shoes.

If you have gray hair, you can use the tone of your hair in your accessories. "Gray" hair can range from platinum/white to pewter, brushed silver, or antique silver. The more muted the hair, the more muted the tone of the metals you will choose for your accessories.

SKIN TONE

Your skin tone is, of course, the exact tone and shade of your skin, ranging from porcelain to peach, linen, warm pink, rose, violet, bronze, amber, cocoa, deep brown, and everything in between. Like everything else about you, your skin tone is unique.

The undertone of your skin—whether peach, pink, blue, or violet—can also help you determine the deeper values of your skin tone. Springs tend to have golden or warm pink undertones. Summers and Winters tend to have cooler rose or violet undertones, while Autumns tend to have ruddy red-orange or copper undertones. You can determine your undertone by looking at your lips and the skin around your eyes and ears. Are your lips purple, bluish, or rose? Or are they golden bronze or peach? Where the skin is thinnest around your eyes and ears, what tone is most prevalent?

You can assess your skin tone by noting which foundation makeup most closely matches your face. You can also look at your blush colors to find slightly warmer values of your skin tone. It can be fun to take your foundation and your blush to the paint store and find swatches that match them both. You can then look for lighter and darker values of both colors to fill in your skin tone palette and accommodate any changes in skin tone that happen with the weather or seasonal cycles.

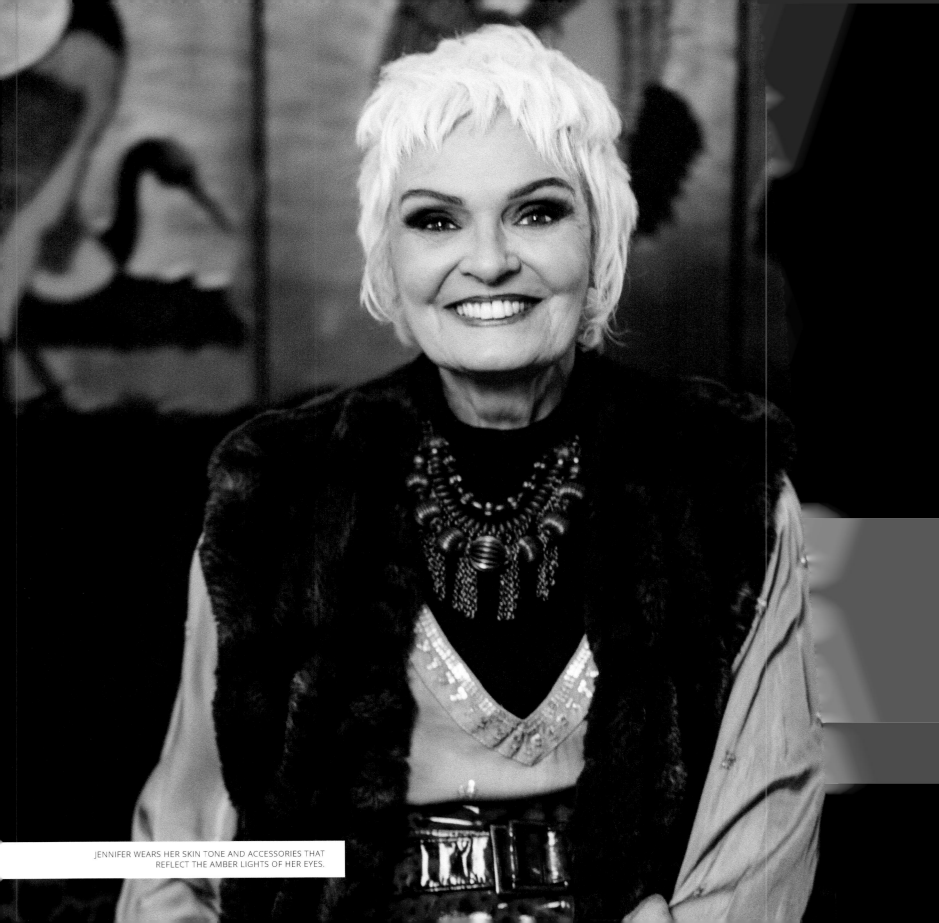

JENNIFER WEARS HER SKIN TONE AND ACCESSORIES THAT
REFLECT THE AMBER LIGHTS OF HER EYES.

Choosing Your
Palette Colors

YOUR NEUTRALS

Let me begin by saying that there is no one neutral color that works for everyone. Just as the lights of your eyes determine many of the key colors in your palette, the combination of your hair, skin, and eyes will determine the best neutral colors for you.

Neutrals are the building blocks of your wardrobe. They're the colors that all your other colors "go with." Black, of course, is considered in the fashion world to be the ultimate neutral, but not everyone can wear it. Individuals with more delicate coloring, like some Springs and Summers, get swallowed up by black; it conceals rather than reveals their essence.

Your neutral colors will be based on your hair and eye colors, and will also complement your skin tone. Your formal neutral will be the darkest value your coloring can support. Your semi-formal neutral can match another value of your eyes (i.e., blue eyes wear gray), while the casual neutral will be a value of your hair. For example, I have a Spring client with clear pink skin, medium brown hair, and blue eyes whose neutrals are black, navy (darkest value of her eyes), rich gray (also reflected in her eyes), and saddle brown (a darker value of her hair). An Autumn client with brown hair, café-au-lait skin, and warm green eyes

has the neutrals of espresso brown, dark olive/khaki (the darkest color of her eyes), chestnut brown (a variant of her hair color), and caramel (slightly deeper than her skin tone). For Winters, neutrals usually begin with black. My formal neutral used to be black, but now it is the silver of my hair. Lighter values of gray (another key Winter neutral) can be found by matching samples to the whites of the eyes, or possibly to the hair.

JENNIFER WEARS HER BLACK AND WHITE WINTER NEUTRALS

JENNIFER WEARS (AND DRIVES!) HER ROMANTIC RED

from cool dusty rose to burgundy. Autumns wear warmer reds like brick, cinnamon, or rust, while Winter reds can range from bright cardinal to deep ruby or magenta. While you may feel disappointed if your favorite fire-engine shade isn't your personal Romantic Red, pay attention to how your skin and eyes light up when you hold your true red up to your face. When you capture the perfect shade for your essence, you will become a beacon for love and connection, passionately lit from within.

YOUR ROMANTIC RED

If you pinch your cheek, you will notice that a deeper flush comes to the surface. This is the blood showing through your skin, the flush of passion. It might be a bright pink, dusty rose, coral, mauve, cinnamon, paprika, rust, burgundy, or bright crimson. This is your Romantic Red, the color of passion and celebration.

By wearing your red, you express and celebrate your passion for life. You will be more magnetic to your partner (or potential partners) and have greater access to the full range of your human emotions. It is truly a potent color.

Your Romantic Red could be any value of red from petal pink to deep burgundy, depending on the undertone of your skin. Springs are often given a bright pink, coral, vibrant ruby, or cranberry, while Summers range

To find your Romantic Red, I suggest gathering all of the red objects in your home—and by red, I mean any value of red ranging from pink to maroon—and bringing them into natural light so you can hold them up to your face. Look at the apples of your cheeks, your nose, or whatever area of your face contains the most red, and gently pat or pinch the skin to bring the blood to the surface. What variation of red do you see? Can you match it? What red makes your eyes and skin glow? What makes you fade into the background?

If you wear makeup, you can also look at your lipstick colors. What red lipsticks look best on you? What are the undertones—violet, blue, coral, rust, or brown? What does this say about your Romantic Red?

YOUR POWER COLOR

You will wear your Power Color when you want to be "center stage" in your work and life. Knowing your Power Color gives you a chance to show up in a color that heightens your energy and amplifies your natural coloring, allowing you to be fully seen while also conveying authority. This is the color of leadership, expertise, and respect.

The Power Color can be one of the more challenging to determine, as you aren't directly matching your hair, skin, or eyes. Instead, lean into your intuitive skills, and also to the instructions below.

For Spring, the Power Color is found in the range opposite of your Romantic Red on the color wheel (complementary color), or in the missing piece of the color triad between your Romantic Red and the lights of your eyes. For example, if you're a Spring and your Romantic Red is a bright ruby and your eyes have gold lights, your Power Color might be a rich emerald (complementary to ruby), or a bright peacock (missing part of the red/yellow/blue triad).

Summers do best with analogous color harmonies (colors that are next to each other on the color wheel), and their colors are generally more subtle than other Seasons. So, a Summer's Power Color will be the strongest within their analogous range, usually in the blue, teal, or violet color groups.

Autumns use analogous colors on the warmer side of the color wheel. If your Romantic Red is a warm brick red (orange undertones), your Power Color might be

emerald or Persian turquoise.

Winters often do best with jewel tones that complement their skin tone as well as the lights of their eyes. As a winter, your Power Color will likely be in the blue or purple family, the strongest of the jewel tones that compliment your hair, skin, and eyes.

If you're still having trouble finding your Power Color, you can hold up some examples to your face alongside your Romantic Red. If your Power Color looks too far out of range—for example, it is cool where your Romantic Red and skin tone are warm, or bright where your Romantic Red is muted—you may need to adjust the hue, value, or intensity of your Power Color until you find the right shade. If you could conceivably wear

JENNIFER WEARS HER POWER COLOR

your Power Color with your Romantic Red, all of your neutrals, and your eye color, you're on the right track.

YOUR SUPPLEMENTARY POWER COLOR

In addition to your primary Power Color (which is the most dramatic color in your palette), you also have a "supplementary" Power Color, which is less strong and inspires less of a reaction than your primary Power Color, but still conveys authority and confidence.

The Supplementary Power Color is usually in a range analogous to your Power Color or your Romantic Red. Depending on your skin tone, your Supplementary Color can either go cooler or warmer than your Power Color.

For example, I had a Winter client whose Power Color was peacock (blue-green). Her Supplementary Color was a deep eggplant (blue-violet) to reflect the violet in her skin tone. A Spring client's Power Color of royal blue was supplemented with a bright teal (blue-green). For a Summer, a Power Color in the blue range might be supplemented by a blue-violet or blue-green tone. For an Autumn, a Power Color of emerald might be supplemented by a bright avocado or a deeper forest green.

JENNIFER WEARS HER SUPPORT COLOR

Your Support Color

Your Support Color is the color you'll want to wear in situations where you want to be supportive to others, foster teamwork, show up as part of a group, or let someone else take center stage. This is a softer color than your Power Color and Supplementary Color, but still complementary to your hair, skin, and eyes.

To find your Support Color, continue around the color wheel from your Power Color. For example, if your Power Color is royal blue, and your Supplementary Color is teal, then your Support Color might be Kelly green (if your skin is warmer). Or, if your Power Color is iris (deep blue), your Supplementary Color might be a blue/violet, and your Support Color might be in the violet range. As the colors relate more closely to the skin tone, they appear softer on the person wearing them.

For Autumns, whose Power Colors are often in the green range, moving in an analogous direction will take them into yellows, which are not necessarily softer than their Power Color. In such cases, we can look at golden browns that reflect the undertones of the skin and eyes. This creates the soft, compassionate effect we are looking for in the Support Color.

For Winters with cooler skin tones, emerald or jade might be the Support Color. These stay in the cooler range while still honoring Winter's drama.

When narrowing down your Support Color, experiment with many different shades and tones. Hold up different fabrics against your face in natural light. Or, go to a flower shop, and buy flowers in shades you think might be your Support Color. Once you hold them up to your face and find the right match, compare the flowers to the items in your closet or in your home to find your perfect shade.

Optional Colors

In addition to all the colors we've explored above, you can add lighter values of many colors to your palette. I call these your "pastels," although many people will not have true pastel shades in their palette.

For Spring essences, the Optional Colors will be all of the other colors in the palette with a higher concentration of white. For example, a lighter pink or coral might be the "pastel" version of the Romantic Red, while turquoise might be the lighter version of the Supplementary Color, peacock.

For Summers, the Optional Colors are muted, dustier versions of the other palette colors. One fun way to

find this is to take a deeper palette color and overlay it with a complementary (opposite) color. For example, you could overlay your Romantic Red with a transparent green. If this new color doesn't appear lighter than the original, overlay it again with an off-white, ivory, or gray. The resulting tone will be "muted." You can do this in any design program on your computer, but it's even more fun at a fabric store! Hold the final tone up to your face and see if it lights up your hair, skin, and eyes.

Autumns do not usually have success with lighter pastel colors, and instead should consider lighter earth tones like wheat, oyster, sand, and corn silk. Lighter brown tones are also an option if they relate well to the hair, skin, and eyes. Imagine a Southwestern desert with its striated earth tones; terracotta is a great inspiration for the lighter side of the Autumn palette.

Winters usually do best with cool, icy pastels, which add a soft element to what is otherwise an intense palette. Since Winters can wear white, adding pure white to any of the other palette colors is a good way to find the Optional Colors. However, it's important to note that, since contrast is essential to the Winter palette, any pastel tones should be combined with formal neutrals like black or charcoal gray or metallics to maintain a level of intensity and drama.

Your Metals

The metallic tones you choose for your jewelry and accessories are an excellent way to bring out your natural sparkle. In addition to your necklaces, bracelets, rings, and earrings, you can wear your metallics in fabrics, belts, belt buckles, purse hardware, and shoe hardware.

Your metallics can be found in the lights of your eyes and also in the highlights of your hair. Far beyond just gold and silver, the metals in your palette might include:

Gold

- Brushed gold
- Florentine gold
- Engraved gold
- Antique gold
- Rose gold
- Black Hills gold
- Gold leaf

Silver

- Brushed silver
- Antique silver
- White gold
- Platinum
- Chrome
- Combined gold and silver

Other Metals

- Bronze
- Antique Bronze
- Brass
- Antique brass
- Pewter
- Copper
- Rose copper
- Oxidized copper
- Copper brown

The level of sheen you can wear in your metals reflects the "finish" and texture of your skin and hair. For example, smooth-textured skin looks best with smooth, shiny metals, whereas highly-textured skin looks best with engraved, hammered, or carved finishes.

Beyond jewelry, metallics are available in fabrics and leather. For instance, a metallic tweed or leather jacket enlivens your wardrobe. Your metallics will match your hair, skin, and eyes. For example, a green-eyed, blond Spring could wear antique brass (eyes), gold (hair), and a peachy copper or pink gold (skin). A blue-eyed, brown-haired Summer might have silver (eyes), rose bronze (hair), and rose gold (skin) as metallics.

The hardest-working, most versatile footwear and handbags are metallics in your hair color. Don't be discouraged if your standard retailers only carry basic shiny silver or gold. There are many options available through Etsy and local artisans.

Discover Your Seasonal Essence

Every color in your palette needs to complement all three components of your hair/skin/eyes Triad. The easiest way to understand this is to see it. If you hold up a color swatch or an item of clothing next to your face, the color will either illuminate and enliven you, making you appear lit by an inner glow … or it won't. It really is that simple.

Using what we've learned in the sections above, test the items in your current wardrobe in natural light. Hold up each item beside your face while looking in a mirror. Do your reds match the blush and undertones of your cheeks, or do they make you disappear? Does your Power Color enliven your entire face, or does it make you look sallow or washed out? Do your neutrals create balance between your hair, skin, and eyes and complement all three?

If you're not sure, try taking full-body pictures of yourself. When you look at the photos, what do you see first—you, or the clothing? Do you see your entire self as a complete picture, or does your body disappear into the clothes, leaving your head "floating" above your body? If you only see the clothes, your essence is being overpowered by those colors. If you only see your face, but your body disappears, the colors are likely too dull or drab for your essence. If your skin looks overly pink or sallow, the color is wrong for your skin tone.

Think of learning your colors as learning a new language. I'm offering you a new way of seeing yourself, and just like learning any other new language, you may feel shy or awkward about using your new skills at first. Or, you may be afraid to misuse your palette or "do it wrong." If that's true for you, fantastic! Discomfort is a message from your body to your brain that you are growing, learning, and becoming more authentic.

Personal growth is often uncomfortable, and always worth it.

On a personal note, here's what I have observed over the course of my forty-year career: Clients who hold images, colors, and clothing up to their face in a mirror learn what works. Just reading the material disconnects the mind from the body, making true learning impossible. So, keep practicing in front of that mirror and your essence will emerge. Once you see it, you can't "un-see" it!

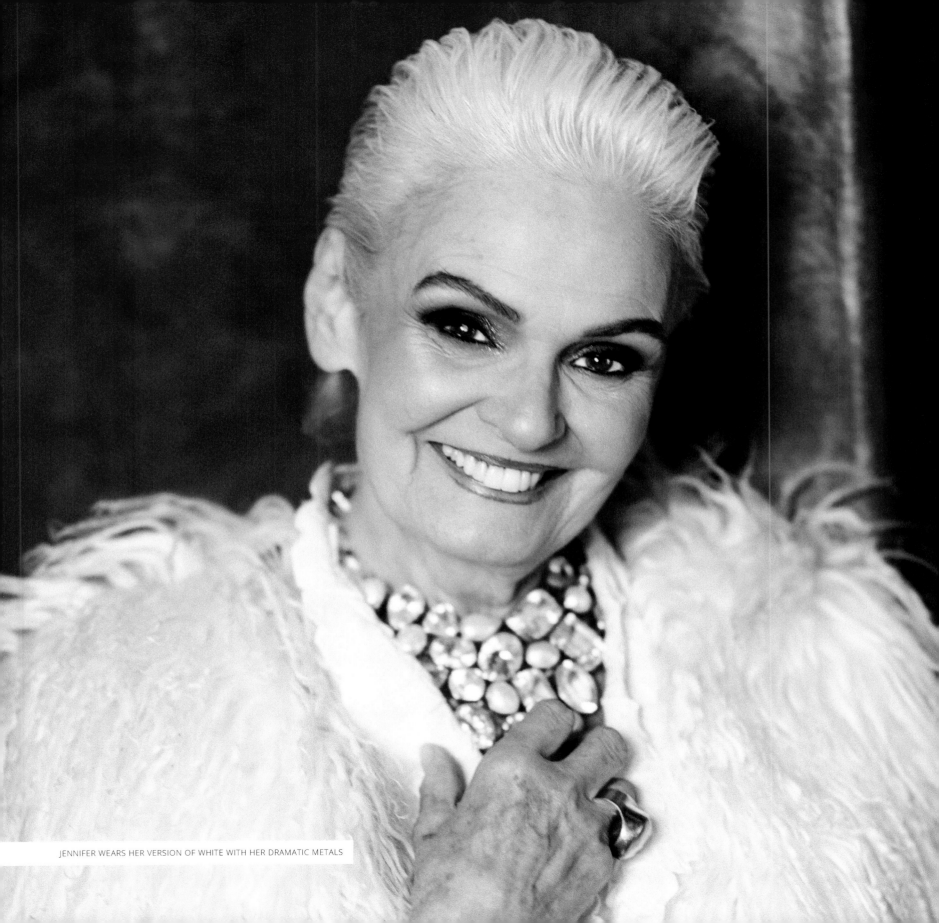

JENNIFER WEARS HER VERSION OF WHITE WITH HER DRAMATIC METALS

"

The time will come
when, with elation,
you will greet yourself arriving
at your own door, in your own mirror,
and each will smile at the other's welcome.

~ Derek Walcott

The Psychology of Color

"Oh, Sue, it's so nice to meet you! You are so beautiful! I can't believe we haven't been introduced before!"

Those were the words of her husband's aunts when greeting my client Sue at a recent family reunion.

The trouble was that Sue had attended that same reunion every year since her marriage nearly twenty years prior, and had been introduced to those same aunts multiple times. There was no evidence that the aunts were having memory challenges. Rather, Sue, an English Summer, had been challenged with regard to her clothing choices.

Before working with me, Sue gravitated toward bright, Spring-like colors that overpowered her muted Summer coloring. She also dyed her naturally dark brown hair a golden blond. This had the effect of "erasing" her face and dusky pink skin. However, at this latest reunion, she was wearing a blouse in her skin tone, Bermuda shorts and shoes in a value of her hair color (brown), and a silk scarf to match the teal of her eyes. She had also returned her hair to its natural

brown. All aspects of her Sacred Triad were present in her outfit, and as a result, she drew the eyes of everyone at the event.

"I realized that, after all this time, they could finally see *me*," Sue shared. "For years, I'd been literally invisible. My clothing was so bright that my face faded into the background. I'm sure the aunts recalled *someone* showing up with my husband—but they never registered that it was me! However, I do not doubt they'll remember me next year!"

Another client, Anne, an Autumn, worked for eight and a half years at the same job without a raise or promotion. She was wearing extremes—either severe black and white with silver and gold, or soft, Summery colors that she'd been told were "more approachable." This had the effect of distancing her from her clients and colleagues, as her natural Autumn warmth was hidden. However, after working with me and learning the psychology of color, she earned five promotions and five raises in just eighteen months. She is now one of the top coaches in her industry. She knows exactly what

colors to wear when she's meeting new clients for the first time, leading a workshop, closing a sale, or negotiating a contract. By wearing the colors that highlight her unique essence in different ways, she's always able to show up as the "version" of herself most suited to the task at hand. The results have been, to say the least, extraordinary.

Your Colors, Your Essence

Dressing your essence is more than just mixing up colors from your palette, although that's the first step. Once we know what colors represent you, we can begin to deliberately select specific colors to support your intention. Do you want to show up as a leader or a collaborator? A loving family member or an authority figure? A romantic hero/heroine or a friend?

Every color has an energy. When the energy of that color matches some aspect of your personal energy and essence, there is coherence, and others will be able to see you fully. This complete visibility is what we have been dialing in by matching the unique colors of your Sacred Triad (hair, skin, and eyes) and your Seasonal essence.

Now, we're going to get a bit more specific.

As you saw in the examples I just shared, the colors you choose to wear from day to day and in different life situations can have a profound impact on how you are perceived and how you are able to navigate work and personal relationships. Each color in your wardrobe has a purpose, and choosing colors to match your intentions

for each occasion is incredibly powerful. When you understand the psychology of color, you can always match your outfit to the specific energy you want to present in a given situation.

Let's begin.

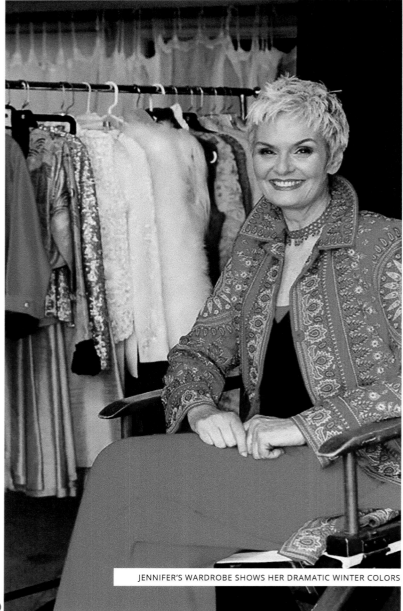

JENNIFER'S WARDROBE SHOWS HER DRAMATIC WINTER COLORS

NEUTRALS: THE BUILDING BLOCKS

As we learned in Chapter 4, neutrals are the foundation pieces of your wardrobe and relate directly to your hair, skin, and eyes. They create a sense of grounding for you and those around you.

The deepest neutral is the most formal. For many people, this will be some variation of black, navy, dark brown, or dark olive. This is the color you would wear to a black-tie event or other important formal occasion.

Your second neutral is semiformal. This color is perfect for slacks, skirts, and other basics and will complement all of the other colors in your palette. Your second neutral can come from your eye color (for example, many blue eyes also contain gray), a lighter value of your hair color (such as a walnut brown for someone with dark brown hair), or a shade to neutralize the skin tone (such as a henna brown or raisin to neutralize rose skin). If you're not sure, consider a dark green, brown, navy, or charcoal gray that complements your eyes, skin, and hair.

Your third neutral is the most casual, and directly relates to or matches your hair color. Collect slacks, skirts, belts, shoes, and other accessories in this color to ground any outfit.

In addition to work and formal attire, your neutrals are also great for T-shirts, jackets and other outerwear, sweaters, workout wear, loungewear, and other wardrobe staples. They can be worn with any color in your palette, or alone with complementary accessories.

However, I caution my clients against building an entire outfit from neutrals. Just as you wouldn't try to drive your car in "neutral," outfits without at least a little bit of color can feel stagnant and uninspiring.

Bringing your eye color and/or your skin tone into the mix can bring more energy to an outfit.

YOUR HAIR COLOR: BALANCING/GROUNDING

JUST A FEW OF THE MORE THAN 4,000 COLORS JENNIFER USES TO CREATE PALETTES

Your hair color is represented in your neutrals, particularly your casual neutrals. However, you can also add lighter variations of your hair color to your wardrobe as "pastels" or additional color options.

Other than black, navy, and gray, which are formal and semiformal neutrals, your hair color is very grounding and adds a whole new dimension to your wardrobe when you use it as a base with all the other accent colors. In particular, shoes in your hair color can ground and elevate any combination of colors. The eye understands the harmony of this pairing, and your brain recognizes the relatedness between you and your clothing.

YOUR EYE COLOR: CENTERING

It is said that the eyes are the windows to the soul. Your essence looks out from behind your eyes. When you wear variants of your eye color, you extend your soulfulness into the physical realm. You will also bring a sense of equilibrium to your overall appearance and foster trust and clear communication with others.

Wear your eye color during negotiations to balance your energy and the energy of whomever is with you. Wear it in family situations where you want to have clear communication with family members and restore balance and calm. Wear it when you ask for a raise, or make an offer on a new home. This is also a great color to wear when practicing yoga, tai chi, meditation, or other spiritual arts, as it connects you to your "inner eye" and self-awareness, creating a sense of centeredness.

Think of your eye color as the hearth of your home, or the centerboard on a sailboat. It's the calm in the storm, the warmth of your heart. Clients have used their eye color when appearing in court, negotiating big deals, and settling family disputes. The more I witness the effects of people wearing their eye color in tense situations, the more I see how remarkable it is.

YOUR SKIN TONE: INTIMACY

Your skin tone color expresses intimacy, relatedness, affinity, and fellowship. It is also the low-key color of our masculinity or femininity. Why? When you wear it, you're essentially naked!

Wearing your skin tone helps build trust. It also makes you more accessible to others, and removes communication

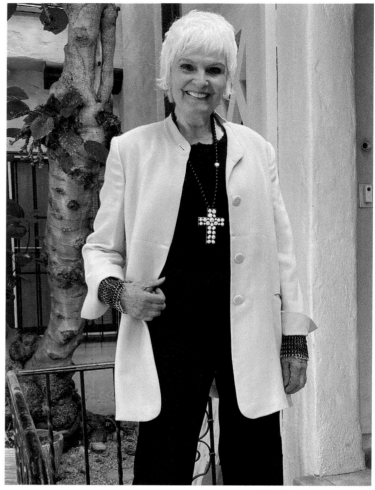

JENNIFER WEARING HER PEACH SKIN TONE

barriers. Wear it when you meet your in-laws, spend time with your parents or children, or on a first date.

The best way to incorporate skin tones into your palette is through shirts and blouses. Skin tones—or variations of them, like tonal pink, peach, or sand—are a great alternative to wearing white or ivory shirts, and can foster a deeper level of connection with others. Springs can include their skin tones in prints or crisp fabrics. Summers can look for romantic lace or floral patterns to

accentuate their dustier skin tones. Autumns can wear their skin tones in richly textured fabrics and pair them with deep browns and terra cottas to mirror the depth of their coloring. Winters should pair skin tones with black or another dark neutral to maintain an appropriate level of contrast.

YOUR ROMANTIC RED: PASSION AND CELEBRATION

In Chapter 4, we found your Romantic Red. When you wear this color, it allows you to be emotionally persuasive and evokes your passion for life. I've heard clients tell me that, when they wear their Romantic Red, strangers spontaneously open doors for them, buy them dinner, and invite them to events!

Many people have a love-hate relationship with red. Some say it represents anger and frustration. Others equate it with blood and horror movies. Countless films, advertisements, and even road signs use red to signal impending danger. On the other hand, red is definitely the cultural color of romance—just think of the red roses we send for Valentine's Day, or the "bombshell" red dresses we see on celebrities. The key to overcoming our associations with red is to take the time to find our red—the shade that truly represents us and showcases our authentic romantic energy. Once you realize that your Romantic Red is an aspect of your beautiful inner light, those other associations will fade.

The best times to wear your Romantic Red are, of course, the times when you desire passion and romance to take center stage. Your birthday celebration, a romantic

evening with your spouse or partner, or a charity presentation where emotional persuasion is key are all ideal occasions to flaunt your red. However, be responsible with this color and set firm boundaries, as it can evoke a range of emotions and passion in others as well as within you!

YOUR POWER COLOR: DRAMATIC PRESENCE

You can incorporate your Power Color into various aspects of your wardrobe, combining it with your neutrals, eye color, and/or skin tone. If you're not comfortable wearing an entire dress or suit in your Power Color, start with accessories like scarves, jewelry, or pocket squares. The goal is not to create yet another "image." Rather, it's to highlight your existing natural energy and confidence. If you're wearing your true Power Color, it will never overpower *you*.

Most of us think of "power dressing" as black suits, white shirts, and gold/silver jewelry. However, that combination really only works for Winter essences; for non-Winters black and white creates distance and disconnects them from others. In this work, "power dressing" isn't about conveying an *image* of power; rather, we are dressing to *amplify our personal power* and our innate leadership and purpose. Your Power Color commands attention in a way that allows you to be perceived as a valued key contributor in any situation.

Besides work attire, you can bring your Power Color into your workout gear (for extra energy), every-day accessories like scarves, and outerwear. Wear it

whenever you want to be seen as a leader or give yourself an energy boost. You can pair it with your neutrals, your skin tone, your eye color, or even your Romantic Red. Your Power Color, and all of your palette colors, relate directly to your natural coloring, creating a powerful visual harmony.

Notice how you feel when you dress with the intention to be seen and exercise your power. Is that exciting for you, or confronting?

YOUR SUPPORT COLOR: NURTURING

Wear your Support Color when you want to be subdued and/or support someone else. This color softens your energy and allows you to be there for others. It calms you and those you're relating to. It also creates a sense of community and connection, something that is really useful when building a team or leading others.

You'll be amazed at the ease you feel in groups when wearing your Support Color! Autumn essences, in particular, can benefit from wearing their Support Color in work settings. Because they are already powerful natural leaders, wearing the Support Color can help foster connections with team members who may be intimidated by their big personalities.

Winter essences can wear their Support Color to make themselves more approachable and reduce the sense of "distance" that is inherent to the Winter energy.

Wear your Support Color when you're out with friends, hanging out with family, working as a part of a team, or trying to find a solution that supports everyone. I guarantee, you'll be amazed by the effect it can have!

OPTIONAL COLORS

As we learned in Chapter 4, these are the lighter values of your other palette colors. Bring these colors into your wardrobe through shirts, accessories, scarves, ties, pocket squares, and lighter, warm-weather clothing. You'll find that these colors coordinate very well with your neutrals and hair color, and can be a fun way to expand your palette while effortlessly coordinating your wardrobe pieces.

Since these colors are lighter versions of your other palette colors, the energy they bring will be "lighter" as well. For example, a lighter value of your Romantic Red may bring emotional accessibility without the intensity. A lighter version of your Power Color may bring a more playful side to your assertiveness.

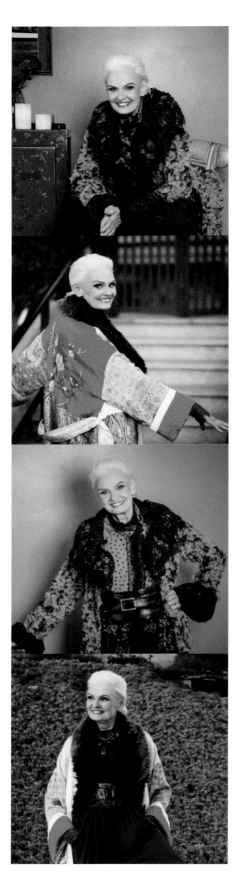

Optional colors are also the perfect choice for home interiors. Consider the lighter value of your skin tone in your family room, a lighter value of your Power Color for your Zoom background, and lighter values of any of your colors in artwork, rugs, and other interior accessories.

YOUR METALS: SPARKLE & SHINE

The metals in your palette bring movement and aliveness to your outfits. Whether you're wearing a full-on metallic dress or suit, or confining your metals to your jewelry, these tones will add energy and pizazz to any outfit.

When I work with clients, one of the most important things I look for are metallics—in shoes, handbags, T-shirts, and fabrics. Metallics enhance many items in your wardrobe, particularly your neutrals. I love looking for metallic mesh scarves, sweaters, and cardigans, and metallic threads in blazers and other outerwear.

The tonality of your metals is key. The level of matte or sheen comes from your hair, skin, and eyes.

Spring

For Spring, we're looking for sparkle and soft sheen. Metals should match the gold of the hair or skin, and can range from bright gold to deep bronze. Pewter, antique silver, or bright silver can match the lights of the eyes, and softer golds can complement Spring's warmer skin tone.

Summer

For Summers, matte finishes and soft sheen offer subtle adornment without overpowering the wearer. Consider rose bronze, rose copper, bronze, pewter, antique silver, and rose gold.

Autumn

For Autumns, mixed metals are favored; from bronze and copper to brass and antique gold, we're looking for depth to match the resonance of their essence.

Winter

For Winters, we match silver to the lights of the eyes or hair, and bring in metallics like copper, antique brass, and brass for those Winters who have yellow or mustard tones in their eyes. White gold and platinum can provide the extreme contrast we are always looking for in Winters.

Dressing with Intention

As you've seen, every color in your palette has both an energy and an intention. Each will evoke a particular facet of your essence and set you up to be well-received by others.

Every time we leave the house, we are promoting ourselves. Whether we are with our family, our loved ones, our colleagues, our friends, or complete strangers, we are making an impression and sharing our energy. Most people can relate to the idea of "auditioning" for a role; if you think of each day as an audition, you will better understand how to dress with intention. If all the world's a stage, how do you show up on that stage?

Here is a simple formula I share with clients to help them choose their outfits for every life circumstance.

- What is the opportunity?
- How do you want to feel in this situation?
- What is the specific result you desire?

When answering the three questions above, make sure you are specific and clear, particularly with regard to the outcome. If there is an event, physical object, or amount of money involved, add it to your intention! The more specific you are, the better you will be able to see which colors need to be present in your outfit in order for you to get what you need.

Here are some examples of client requests, and the color choices I recommended.

- "I'm going on a first date. I want to feel beautiful and desirable, and I want the person to call me again for a second date." In such a case, I would encourage the person to wear their skin tone with one of their neutrals.
- "I'm supporting my daughter at a music audition. I want to feel present and calm, and I want her to feel like she can lean on me no matter how it goes." In this case, the Support Color with a casual neutral would be a great choice.
- "I have a job interview. I want to feel confident and assertive but also be seen as a team player. I want to secure this new position at the top of the offered salary range, which is $150,000." As you may have guessed, a combination of the Power Color and Support Color may be best here.
- "I'm going to a family reunion. I want to feel comfortable, confident, and approachable. I want my relatives to see me for who I am today, not who I was as a kid." In this case, the skin tone with accents of the Supplementary Color or eye color might be a wise choice—all grounded by shoes and accessories in the hair color.

We don't have full control over everything in our lives, including how others see us. However, applying the psychology of color can help us be fully present and communicate our intentions moment by moment. This work brings a whole new level of consciousness to the way we dress.

In my experience, when people practice this intention-setting with their clothing choices, they win in court, find their life partner, feel in harmony with their families, and manifest their dreams. You can choose to celebrate yourself through your clothing, be fully present in your life, and make a difference in every situation you face. You can raise the vibrational energy of all those important moments in your life—which is every moment, every day.

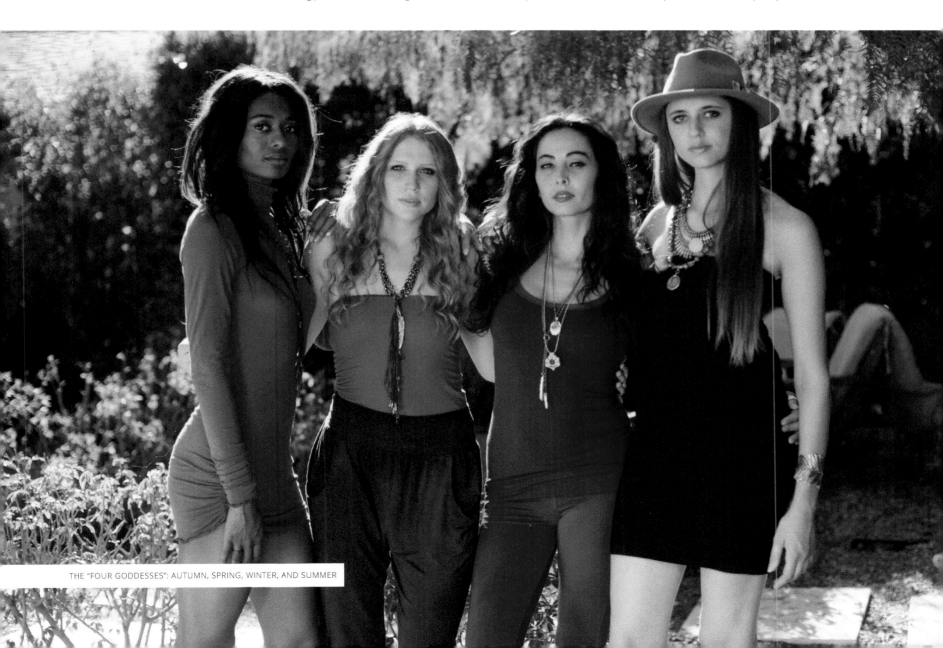

THE "FOUR GODDESSES": AUTUMN, SPRING, WINTER, AND SUMMER

"

Glamour is all about feeling
good in your own skin.

~ Zoe Saldana

The Seven Principles
of Design

We say we want to be fully expressed, yet many of us have a fear of being fully seen. As a consequence, many people dress in ways that hide them. Even once we have identified our Seasonal essence and our core wardrobe color palette, we may tend to dress in shapes, patterns, or designs that are not a perfect match to our essence. Or, we may not be adding key components like appropriate jewelry and accessories to our outfits, which can also have the effect of minimizing or hiding our essence.

For example, I have a client, an Autumn, who is an amazing jewelry designer. When she attended a recent retreat with me, I asked her to appear on the first day without any jewelry or accessories. Although she was wearing her colors, the ensemble felt incomplete. Autumns in particular need complexity and movement; think of falling leaves swirling in the wind, or the constant motion of a crackling campfire. When my client walked in with no accessories, everyone in the room immediately noticed that her energy felt subdued. But when she added three pieces of jewelry in her metallics, the look completely changed. Now, we could see her dynamism and energy, as well as her natural coloring.

In this chapter, you'll learn how to turn dressing into an art form so that you live as a moving, breathing work of art. You'll discover the Seven Principles of Design, and learn how to use the natural design of your body, face, features, hair, and skin to select the right fabrics, clothing shapes, jewelry, and accessories to create balance and harmony. Applying the Seven Principles aligns your appearance with your essence and fully supports your life force.

The Defining Details

The work of art that is you contains more than just colors. You have your own unique combination of visual factors that come together to create your personal style. These elements inform your wardrobe in various ways, including the fabrics and accessories you choose.

There are seven key principles of design that offer greater context, guidance, and depth to the art of dressing your essence:

- *Principle #1:* Contrast
- *Principle #2:* Texture
- *Principle #3:* Complexity
- *Principle #4:* Scale and proportion
- *Principle #5:* Sacred geometry
- *Principle #6:* Visual weight
- *Principle #7:* Print selection

These principles are every bit as important to dressing your essence as your color palette. Like your colors, they will mirror elements of you, allowing your true beauty to emerge and be seen by others.

One of my long-time clients, an Autumn, worked at a university. For years, she wore pastel suits, thinking that they were better suited to the warm climate where she lived and worked. Her job was to create and lead conferences, but in those lavender and pink suits, she disappeared. She didn't understand why people wouldn't listen to her! However, when we dressed her in her native level of contrast (Design Principle #1), in suiting of olive and terracotta, added necklaces, a scarf, and a textured jacket (Design Principles #2, #3, and #6), she stood out like the confident, capable leader she was. Suddenly, she was perceived as the authority in any room she entered. Years later, when we were out shopping together, people would stop her on the street or in

the stores and comment on the events she'd organized. Even though they'd met her only once, in some cases more than a decade earlier, she stood out in their minds. That's the power of great design.

Let's begin.

Principle #1: Contrast

Contrast, put simply, is the measure of the difference in color value between your hair, skin, and eyes. The greater the difference between the coloring of your hair and skin, eyes and skin, and eyes and hair, the more contrast you will be able to wear in your clothing and accessories.

We want our natural level of contrast to be reflected in the clothing and accessories we choose. When we wear our native level of contrast, we make ourselves fully visible because our clothes are repeating our natural coloring, giving an overall picture of symmetry, coherence, and integrity. If we wear too high a level of contrast, people will see our clothes before they see us; in essence, rendering us invisible. On the other hand, too little contrast will draw all the attention to our face and hair, and our body will disappear, creating a sense of "detachment" or disembodiment.

The highest level of contrast in a wardrobe is, of course, black and white. The lowest level of contrast is subtle shades of a single color. Medium contrast can be just about anything in between, such as navy blue with sky blue, chocolate brown with taupe, burgundy with gray, or black with saddle brown.

THE CONTRAST QUIZ

To determine your natural level of contrast, get out your mirror and stand in natural light. Then, assign a value of light, medium, or dark to your hair, skin, and eyes.

Hair	Skin	Eyes
☐ Light ☐ Medium ☐ Dark	☐ Light ☐ Medium ☐ Dark	☐ Light ☐ Medium ☐ Dark

High Contrast

Opposite values
(dark + light)

If you are a high-contrast person, you have strong coloring. You can wear black and white, black and silver, black and gold, and other opposite values within your palette. All Winter essences are high-contrast people.

Medium Contrast

Medium or consecutive values
(dark + medium or medium + light)

If you are a medium-contrast person, you will want the shades you choose to mirror the difference in the values of your hair, skin and eyes. Most Spring and Autumn essences will be medium-contrast people.

Low Contrast

All one value
(light + light)

If you are a low-contrast person, you will want to choose shades with similar values to create a "blended" effect across your entire palette. Summers with light hair, skin, and eyes or medium hair, skin, and eyes are low-contrast people. Many Summers have both light and medium values in their hair, skin and eyes, and are therefore low- to medium-contrast people.

The difference between your most extreme values will determine the amount of contrast you can carry.

For example, if you have brown eyes, dark hair, and pale skin (dark + dark + light), you are a high-contrast person. However, if you have blond hair, blue eyes, and light skin (light + light + light), you are a low-contrast person. If you have deep brown hair, olive skin, and hazel eyes (dark + medium + medium) or medium brown hair, pale skin, and blue eyes (medium + light + light), you are a medium-contrast person.

If you are a darker-skinned person with dark hair and eyes, you can find your personal level of contrast in the whites of your eyes and the color of your teeth. Bright white creates high contrast, bone white or soft yellow creates medium contrast, and soft gray or beige creates low contrast.

A NOTE ON HAIR COLOR AND CONTRAST

Hair and skin usually provide the highest levels of contrast in someone's palette. Therefore, when we are looking to bring forward our essence, we need to look closely at the hair color we were born with and the color we have chosen.

When working with clients, particularly women, I often find that they have habitually lightened their hair because they've been told light hair is more attractive. However, when we lighten our hair beyond our natural range—for example, our hair color as a younger child, or the shade we would typically see after spending a summer in the sun—we reduce the contrast between our hair and skin, which makes us "fade out." It literally dims our essence and our natural glow. This happens quite often for Winter essences, who love the drama of platinum blonds and are often attracted to the playfulness of Spring energy.

Some people choose to darken their hair. This can have the effect of creating greater contrast, which can create a mismatch with our natural energy. This is particularly true for Spring and Summer essences. For example, a Spring who colors her naturally dark blond hair black or dark brown will lose some of the vibrancy inherent to her essence; what others see will therefore be at odds with the truth of who she is.

There is *nothing* wrong with your natural shade. Mother Nature makes no mistakes. If you really want to see yourself *as* yourself, consider what it would feel like to bring your hair color closer to its natural shade. If you're not sure what your natural shade is, look at your eyebrows. Your natural hair color is likely within one to two shades of your eyebrow color.

FORMERLY A BLEACHED BLOND (LEFT) RAKALAYA, A SPRING, GLOWS WEARING HER NATURAL HAIR COLOR (RIGHT)

YOUR VERSION OF CONTRAST

Within your palette, you can create your own version of low, medium, and high contrast, even if you are a low- or medium-contrast person.

High Contrast

Most formal, highest energy

You can create your version of high contrast by combining the very darkest and very lightest colors in your palette.

Spring: navy + bone white or ivory

Summer: navy + pink or skin tone

Autumn: espresso brown or dark olive + ivory

Winter: black + stark white

Medium Contrast

Semiformal, medium energy

Create medium levels of your contrast by combining your semiformal neutral with another palette color.

Spring: navy + an accent color like turquoise, coral red, or French blue

Summer: navy + burgundy

Autumn: espresso brown or dark olive neutral + rust red

Winter: black + royal blue or another jewel tone

Low Contrast

Least formal, subtle energy and relatability

Create low levels of your contrast by combining a neutral with a palette color of similar value.

Spring: navy + brown, ivory + skin tone, or eye color + a related accent color

Summer: navy + charcoal, bone white + skin tone, or monochrome dressing with multiple shades of a single color

Autumn: espresso+ olive, ivory + skin tone, or a combination of your Power Color, Supplemental Power Color, and Support Colors (i.e., emerald, avocado, and gold)

Winter: black + charcoal, white + skin tone

Principle #2: Texture

This principle is about reflecting the textures present in our hair, skin, and eyes in fabrics and accessories. Like contrast, texture will reflect the variations in our natural design. As in all else, we look to Mother Nature for inspiration and guidance. The design pattern created in you is the perfect design to showcase your inner essence.

Texture falls into three categories: low/smooth, medium, and high/rugged. We determine the amount of texture in your natural composition by examining four factors: your hair, skin, facial features, and natural animation.

HAIR

Your hair is one of the most obvious places to look for texture.

How many shades does your natural hair color contain? Is it solid black, brown, blond, or red? That's low/smooth texture. Does it have some natural highlights? That's medium texture. Does it contain many shades, like salt and pepper or several shades of blond? That's high/rugged texture.

Now, look at the shapes your hair takes when you let it dry naturally. Is it straight and smooth (low)? Wavy (medium)? Curly or kinky (rugged/high)?

SKIN

Like the bark of a tree, skin can be smooth, medium, or rugged. All are beautiful, and no one type is better than the others.

If your skin appears to have one tone overall, without freckles, pigmentation, or variations, you have low/smooth textured skin.

If your skin is basically one tone but you have a bit of color in your cheeks, some pigmentation or subtle variations, or light wrinkling, you have medium-textured skin.

If you have many freckles, deep wrinkles, or lots of color variation, you have high/rugged textured skin.

FEATURES

Now, let's look at your facial features—your eyes, eyebrows, nose, and mouth. The more variation in size between your features, the more texture is created.

Are your features consistent in size? If so, you have low/smooth textured features.

Is there subtle variation in your features? For example, do you have small eyes but a medium nose and mouth? If so, you have medium-textured features.

Is there a lot of variation in your features? For example, do you have large eyes and thicker eyebrows but a smaller nose and mouth? Or do you have small eyes, a larger nose, and a medium mouth? If so, you have high/rugged textured features.

ANIMATION

Finally, let's look at animation. This is the amount of movement in your facial features when you speak.

Some people are naturally still, and have very little expression in their face when they talk. They appear like a still-life portrait with only minimal movement. These people therefore have low/smooth texture. Others move their eyebrows, narrow their eyes a bit when they smile, or flare their noses when they speak. These people have medium texture. Still others bring lots of movement to their face and body when speaking. They talk with their hands, wrinkle their eyes when they laugh, have big dimples, and always appear to be in motion. These people have high/rugged texture.

THE TEXTURE QUIZ

Let's put everything together to determine your level of texture.

	High/Rugged Texture	Medium Texture	Low/Smooth Texture
Hair	☐ Curly, textured, many shades	☐ Wavy, a few shades	☐ Straight, smooth, one shade
Skin	☐ Freckled, wrinkled, varied pigmentation	☐ Some variations in color and consistency	☐ Smooth, one shade
Features	☐ Varied in size	☐ Subtle variation	☐ All one size
Animation	☐ Very animated and expressive	☐ Some movement	☐ Features appear still or static

HOW TO WORK WITH TEXTURE

Be sure to reflect your natural level of texture in the fabrics and accessories you choose.

High/Rugged Texture

High/rugged texture has lots of tactile interest and complexity. Think herringbone, tweed, heavy corduroy, raw silk, cable knits, chenille, and beaded fabrics. In accessories, look for wood, tortoise, or mixed-metal jewelry with multiple colors and sizes within each piece. Exaggerated design is the focus here.

Medium Texture

Medium texture is slightly more complex and has a bit more depth. Think suede, mohair, flannel, ribbed knits, French terry, embroidery, or lace. In accessories, look for mixed metals—i.e., gold with silver, or bronze with gold—with slight variations in size and color (such as beaded necklaces with a few different colors or bead sizes).

Low/Smooth Texture

Low/smooth texture is simple, often with a bit of sheen. Think satin, cashmere, gabardine, jersey, rayon, or velour. In accessories, look for smooth metals and simple designs, such as smooth, uniform pearls, a simple gold chain, or a smooth silver ring.

Principle #3: Complexity

Complexity is the amount of movement and design you can wear in your outfits—in other words, the amount of "busyness" in your ensemble. Where texture and contrast take into account your natural features, coloring, and design, complexity is more related to your personal energy. The amount of complexity you wear creates congruency between your inner and outer self.

The way you dress is a visual language you can use to express yourself. It sets up an expectation for those looking at you—particularly when it comes to first impressions. The amount of movement and drama as well as contrast and texture in your outfits will speak volumes about your personal energy and what kind of person you are.

Complexity is one area of style where I see a lot of incongruency. Many strong people, particularly Autumn essences, tone down their natural complexity to avoid being seen as "too strong." On the other hand, many gentle Summers play up complexity to project an image of greater power and authority. However, when your clothing projects an accurate image of your inner self, you will always appear powerful, authentic, and radiant. Gentleness is not weakness. Strong is not the same as overpowering.

THE COMPLEXITY QUIZ

In order to assess your natural complexity, we will look at factors from your texture quiz as well as your natural preferences and level of energy.

	High Complexity	Medium Complexity	Low Complexity
Texture	☐ High/Rugged	☐ Medium	☐ Low/Smooth
Movement & Speech	☐ Energetic walk ☐ Lots of body movement ☐ Speaks rapidly or with lots of gestures	☐ Medium momentum ☐ Some body movement ☐ Speaks with some modulation and gestures	☐ Slow, methodical walk ☐ Doesn't like to rush ☐ Speaks slowly, quietly, or with little animation
Personality	☐ Very energetic ☐ Highly extroverted ☐ Gives detailed answers to questions	☐ Sometimes energetic ☐ Balance of introvert/extrovert ☐ Gives prompt replies	☐ Low-key ☐ Introverted ☐ Gives simple answers to questions
Style	☐ Prefers several colors, textures, and prints	☐ Prefers some color with neutrals	☐ Prefers tone-on-tone dressing

HOW TO WORK WITH COMPLEXITY

Your natural level of complexity will be reflected in the amount of design you choose to wear and how you combine various elements in your outfits. The idea is to repeat the design patterns of your face, hair, and skin, as well as the way your body moves, so that you invite people to lean into who you are and what you're creating. Additionally, we can look at your complexity as a range to give you more day-to-day flexibility. Are you simple-to-medium complexity? Medium to high? High to "Wow!"? The choices you make will be determined by your current energy level and also the occasion for which you are dressing.

High Complexity	Medium Complexity	Simple Complexity

High complexity includes lots of movement and contrasting textures. For example, layered necklaces, earrings, and scarves; multiple patterns and fabrics in a single outfit; and layered dressing all create complexity and movement.

Medium complexity brings a bit more movement into the equation. Design is interspersed with space—for example, jeans with a printed blouse and a suede jacket, paired with a necklace, earrings, and a belt; or a dress in a subtle pattern with bracelets and a belt, but no necklace or earrings (all in your Seasonal colors, of course).

Simple complexity is classic and clean, without many visual distractions—for example, a solid satin sheath dress and plain shoes with a few slim bracelets and small stud earrings, or a column of a single color.

We can also look at complexity according to Seasonal essence. Often, complexity follows these guidelines:

- *Spring:* simple to medium complexity in lighter-weight fabrics and metals
- *Summer:* medium to high complexity in lighter-weight fabrics and metals
- *Autumn:* medium to high complexity in heavier-weight fabrics and metals
- *Winter:* extreme complexity (very simple or highly complex) in heavier-weight fabrics and metals

Principle #4: Scale and Proportion

Whatever clothing, jewelry, accessories, and prints you choose, it's vital that they match your natural design.

In nature, we see a perfect balance of scale and proportion. The bloom of every flower is offset perfectly by the shape and size of its leaves. Violets or crocuses would look quite out of place on a rosebush, but roses are perfectly highlighted by the dark green leaves and thorns. The proportion of a fish's fins, a tree's branches, or a wolf's eyes in relation to its entire self is perfect and unique. There are no wrong proportions, only the right ones for your unique composition.

We determine scale and proportion by examining two elements: the size of your head in relation to your body, and the size of your features in relation to your face.

If you have a small head/face relative to your height and small features, you will wear small prints and small accessories. If you have a larger head/face relative to your height and large features, you will wear large-scale prints and accessories. If you have a medium head/face but small features, you will wear small to medium prints and accessories, and so forth.

Scale and proportion are about repetition. Proper scale and proportion give the body a sense of appropriate balance. We want to repeat your natural design in all of your clothing, accessories, jewelry, and so forth because when you are surrounded by patterns and shapes that repeat your natural design, your essence emerges. When you choose prints and accessories that clash with your natural proportions, the distortion makes it difficult for others see and hear you. The focus shifts away from your message and onto what doesn't work. People see what you are wearing, not you.

THE SCALE/PROPORTION QUIZ

In relation to my body, my head is:

☐ Small ☐ Small/ medium ☐ Medium ☐ Medium/ large ☐ Large

In relation to my face, my features are (place a check mark in the appropriate column for each row):

Eyes	Brows	Nose	Mouth
☐ Small ☐ Small/medium ☐ Medium ☐ Medium/large ☐ Large	☐ Small ☐ Small/medium ☐ Medium ☐ Medium/large ☐ Large	☐ Small ☐ Small/medium ☐ Medium ☐ Medium/large ☐ Large	☐ Small ☐ Small/medium ☐ Medium ☐ Medium/large ☐ Large

Additionally, or if you're having trouble with the exercise above, you can examine whether your features are "compact" (meaning, close together) or farther apart. Measure the space between the center of your eyebrow and the corner of your mouth. On average, that space is three to five inches. If your measurement is closer to three inches you have compact features and therefore should wear smaller prints and smaller accessories. If your measurement is closer to five inches or more, you have larger features and therefore wear larger prints and larger accessories.

If you have a head-to-body proportion that is different than the proportion of your facial features—for example, a larger head with smaller features—you will blend these by choosing larger-scale prints or shapes with small embedded details. This might mean a paisley print with small design details, a large necklace with many small inset jewels, and so on.

Principle #5: Sacred Geometry

As all of nature unfolds according to the principles of sacred geometry, so too does your beautiful body.

When I look at my clients' features, what I see are shapes: triangles, ovals, circles, teardrops, diamonds, etc. All are beautiful, and all create balance and harmony when repeated in clothing and accessories.

Many of us were taught that we should dress to "balance" our natural shape—and, in particular, to minimize anything that isn't in alignment with fashion norms. However, that does not call forth our essence or repeat our natural shapes. It makes us disappear. Instead, we need to learn to work with our personal sacred geometry and allow our body to show us where and how to adorn it.

We will begin by looking at the shape of your face. The most common face shapes are round, oval, square, rectangle, heart, inverted triangle, and triangle.

Round

The round face has a soft arch along the forehead and jawline, and width in the cheekbone area.

Oval

The oval face also has a soft arch along the forehead and jaw but is more elongated and narrow than the round face.

Square

The square face has more width, with a broad, wide forehead and jawline with relatively straight sides.

Rectangle

The rectangular face is similar to the square in that the forehead is broad and wide, and the sides of the face are straight, but it is more elongated and narrow.

Heart

The heart-shaped face has a broad forehead with a tapered jawline. The taper begins at the earlobe and ends at the chin.

Inverted Triangle

The inverted triangle face has a broader forehead with a narrower, tapered jawline.

Triangle

The triangle face is broader at the jaw than at the forehead.

OTHER FEATURES

There are other shapes present within the overall design of your face that are also helpful to know. Your eyes, nose, and mouth determine what shapes are contained in your prints and accessories.

EYES, BROWS, AND EYE SOCKETS

Your eyes fall into one of a few shape categories.

Teardrop	Almond	Round	Half-Moon
Teardrop eyes are pointed on one side and rounder on the opposite side.	Almond eyes are pointed on both ends, and the lid spacing is more even.	Round eyes are curved on both the top and bottom, coming to soft points on both ends.	Half-moon eyes are straight on the bottom and curved on top.

Your brows also have a distinctive shape.

Arched	Wedge	Triangle
Arched brows create a soft half-circle shape.	Wedge brows are more of a straight line from end to end and tend to be thicker.	Triangle brows have a distinctive point in the center.

Your eye sockets also have a general shape. For some, the eye sockets are very round. For others they are more oval, rectangular, or even triangular.

NOSE

Like your eyes, your nose will likely fall into one of the following shape categories:

Aquiline	Rectangle	Teardrop	Triangle	Button	Piquant
Aquiline noses are angled like an eagle's beak.	Rectangle noses feature a straight line from the bridge to the end of the nose.	Teardrop noses have a narrow bridge and a slight flare, and come to a soft point.	Triangle noses are narrow at the bridge and wider at the bottom.	Button noses are rounded at the end.	Piquant noses are curved, with the end of the nose turned up in a point.

MOUTH

Straight	Triangle	Arched	Pouting
A straight mouth is straight across, especially in the center beneath the Cupid's bow.	In a triangle mouth, the points on the upper lips create a two triangles.	In an arched mouth, there is almost no point in the center of the top lip.	A pouting mouth appears rounded and full.

WHAT YOUR FACIAL GEOMETRY TELLS YOU

The angle of your jawline determines the angle of your shirt collars.

For example, round and oval faces look best in scooped or oval necklines. Square and rectangular faces look best in square necklines or crewnecks. Inverted triangle and diamond faces look best in V-necks.

If you measure the distance between your hairline and your chin (usually around eight inches), you will know the ideal depth of your neckline, scarf, or lapel. The longer your face, the deeper the collar/neckline. When it comes to dress shirts, those with longer faces can leave the top button unfastened to create a deeper neckline.

The rest of your facial features will show you what accessory shapes to choose. For example, if you have almond eyes, you can mirror that shape in your jewelry (think longer, tapered beads or gemstones) and choose prints with almond-like shapes. If you have round eyes and a pouting mouth, you can wear circular shapes in your jewelry, prints, and accessories (think hoop earrings, scalloped edges, polka dots).

Principle #6: Visual Weight

The principle of visual weight is all about fabric and accessory choices that match the "weight" of your hair, skin and eyes, and also the weight that goes with your Season.

- *Spring:* light weight
- *Summer:* light weight
- *Autumn:* heavy weight
- *Winter:* heavy weight or extremes of light and heavy weight

In order to determine what visual weight is right for you, we will look at four factors:

- *Your hair.* Is it fine? Medium? Thick or highly textured?
- *Your skin.* Is it one shade? A few shades? Or does the pigment vary?
- *Your features.* Are they consistent in size? Some variation? Widely varied?

We will assess all of these factors in the Visual Weight Quiz on the next page.

However, let's first find your body type.

YOUR BODY TYPE

There are three main body types.

- *Skeletal body types* have a wiry, taut frame and are bonier in structure. They can wear fabrics that have body, structure, and stiffness, such as suede, leather, raw or Thai silk, velvet, corduroy, broadcloth, flannel, tweed, linen, or quilted fabrics. I think of these dense fabrics as "filling out" the skeletal body.
- *Muscular body types* are more athletic and solid. They need semistructured shoulders and fabrics that move with them, yet retain their shape. Stretch denim, gabardine, silk knits, velour, boucle knits, and jersey fabrics work well for muscular types.
- *Molded body types* are Rubenesque and curvaceous, with a fuller bust, tummy, and derriere. They need fabrics with softness and drape, like cashmere, chiffon, mohair, sheer wool, soft knits, or rayon jersey. These can be worn in fluid shapes like sweater dresses, collarless shirts, or soft suiting.

THE VISUAL WEIGHT QUIZ

	High Visual Weight	Medium Visual Weight	Low Visual Weight
Features	☐ Larger, more prominent	☐ Medium	☐ Small and refined
Hair	☐ Thick hair shaft or dense/heavy hair	☐ Medium thickness and texture	☐ Fine/thin
Skin	☐ Textured with pigment variations	☐ Medium weight and texture	☐ Thin, delicate, transparent

Thick hair, prominent features, and pigmented skin call for fabrics and accessories with heavier visual weight. Medium-weight hair, skin, and features call for medium-weight fabrics and accessories. Lightweight hair, skin, and delicate features call for lightweight fabrics and accessories. A combination of elements—for example, thick hair, medium features, and delicate skin—requires a mixture of fabrics and accessories. When choosing a fabric, take into account how that fabric moves with your body and suits your body type.

Principle #7: Print Selection

To me, prints represent the animation of our life force. They give movement to our clothing and, when properly chosen, mirror the energy of our personality and essence. They highlight what makes us interesting, like exclamation points or underlines.

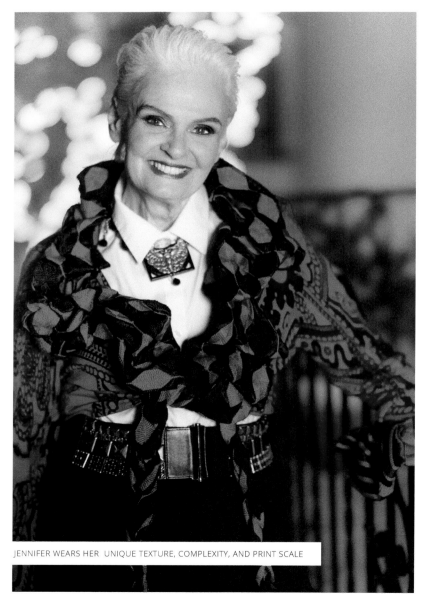

JENNIFER WEARS HER UNIQUE TEXTURE, COMPLEXITY, AND PRINT SCALE

Although I've mentioned prints in other principles, I always save this discussion for last because print selection requires putting our knowledge of the first six principles—contrast, texture, complexity, scale, geometry, and visual weight—to work.

In particular:

- *Contrast* is determined primarily by your Season.
- Your natural level of *complexity* will match the "busyness" of your prints.
- The *scale* of your head to your body, and your features to your face, will determine the size and scale of your prints.
- The *shapes* of your features will appear in your prints.
- Your level of *texture* and ideal *visual weight* will be reflected in the fabrics you choose.

For example, I have a small face for my height. My features are close together (compact) and small to medium in size. My ideal prints are small and close together with a high level of contrast to fit my Winter essence. If I choose prints that are too large or with patterns spaced too far apart, they totally overpower me.

Let's look at each area of print selection in depth.

CONTRAST

Springs and Summers need prints that are lower in contrast. When the hair color is part of the print, they can increase contrast to medium. When in doubt, these two Seasons should go for a more blended print. Autumn prints stay in the medium contrast range to express more energy. Only Winters can successfully wear high-contrast prints.

High-Contrast Print Medium-Contrast Print Low-Contrast Print

COMPLEXITY

The more shapes, patterns, colors, or details present in a print, the more "complex" it is. For example, stripes and polka dots are low-complexity prints, while tapestry, paisley, or animal prints can range from medium to extreme complexity, depending on the design and colors.

SCALE AND PROPORTION

The size of the pattern being repeated determines the scale of the print. Small prints are delicate and tiny, while larger prints take up more space and may include more negative space. If you have a larger face with smaller features you can wear a larger print with smaller inner detail.

You can determine the spacing and scale of your ideal prints using the following measurements:

- The top of your forehead to the center of your eyebrow.
- The center of your eyebrow to the corner of your mouth.
- The corner of your mouth to your chin.

Compact features will usually show a three- to five-inch spacing. More widely spaced features will look best with spacing of five to six inches. These measurements will give you the ideal spacing for your prints. For example, if you are buying a plaid or stripe, the space between the stripes/lines should be no wider than your widest measurement, and no closer than your smallest.

Large-Scale
Print

Medium-Scale
Print

Small-Scale
Print

SHAPE/GEOMETRY

The shapes of your face and facial features should be mirrored in your prints. For example, if you have a round face, you can look for prints with circular elements. Repeat the shapes of your eyes, brows, lips, and nose in your prints.

This also applies to the composition of your jewelry. For example, teardrop eyes might be reflected in a teardrop pendant or earrings. A triangle nose might be seen in the pattern of a scarf, as well as in a necklace or earrings.

VISUAL WEIGHT

These elements will influence the fabrics you choose for your prints. For example, if you have low/smooth texture, silk or satin fabrics may work well, while if you have rugged texture and require a heavy visual weight, you may choose very textured fabrics. As a rule of thumb, Springs and Summers require a lighter visual weight; Autumns and Winters wear a heavier visual weight.

Completing the Artwork

All this can seem overwhelming. I encourage you to take just one step at a time. Whenever in doubt, stand in front of a mirror and hold the item in question up to your face.

Ask yourself: Is this in balance with my face? Is it too dull? Is it too strong? Does it overwhelm me? Does it drag me down or enliven me?

If it feels right, keep it. If not, release it!

"

Just be yourself.
There is no one better.

~ **Taylor Swift**

The Spiritual Principles of Dressing

After many years of seeing fashion as an art form, it was revealed to me that it is, in fact, a spiritual practice—a sacred expression through which the loving essence of *us* can be revealed tangibly and visibly.

As I shared in Chapter 1, my own desire to awaken to my true nature led me on a personal spiritual journey. One fundamental part of that journey was my time studying spiritual psychology under Drs. Ron and Mary Hulnick at the University of Santa Monica.

I learned of their program through my friend and fellow artist, Jasmine Knauer. She designed beautiful clothing that she manufactured in Bali, and I often took clients to her Los Angeles boutique to find unique pieces. She was always very calm, and there was something different about her way of moving through the world. Where others had stress and questions, she had purpose and peace. When I asked how she had cultivated this way of being, she told me about the spiritual psychology program she'd attended at the University of Santa Monica.

I had heard of the program, and had even applied a few years before, but the timing wasn't right at that point. I wanted to learn to radiate my inner light the way she did, so I decided to revisit my application. This time, when my application was accepted, I dove in.

Dr. Mary (who was also gracious enough to write the foreword to this book) teaches foundational spiritual principles that provide a "guidebook" of sorts for her students to navigate life, work, and relationships. On the first day of classes, she and her husband and co-teacher, Dr. Ron Hulnick, explained that *we are spiritual beings having a human experience*, not the other way around. Of course, I'd heard similar things before, but for some reason their words struck me deeply. Suddenly, I realized that I had been working very hard in my life to "be spiritual," but in fact, "spiritual" was everything I already was!

This really turned things around for me. I began to see myself as a whole and perfect being, not a flawed, imperfect vessel. I was finally able to let go of my life-long need to "improve" myself and instead focus on

being more of the divinely-designed work of art that was present from the moment I was born. If I was already complete, there was nothing to change; life was going to change me naturally, in its own beautiful way. My only task was to embrace this natural flow to the fullest—to grow in wisdom, cultivate grace, and bring my whole self to each and every moment.

As my studies unfolded, I continued to work with clients every day. I noticed that many of them were struggling with the same issues of "not-enoughness" I had been feeling. I already knew that my work helped people improve their confidence, success, and charisma, but now I began to examine how color related to spiritual psychology and the experience of unconditional self-love. After all, as we've explored, every color has a feeling and a vibration, all its own. Surely, there must be a resonance between our spiritual selves and the colors that honor our divinely-inspired physical form. We each have a constellation of colors that vibrate to make us unique and recognizable.

I wondered, "How can we use color to express ourselves spiritually? How can we use color to empower ourselves to experience greater self-love, belonging, and purpose?" During my USM studies, I recognized that my work is actually a healing profession. Helping clients fall in love with their perfect selves, became my primary focus. More than that, I wanted to be a loving witness for them in their unique processes.

So, I started experimenting on myself. I asked, "What would it look like for me to be fully expressed, with no rules or reservations?" How much could I embrace the drama of my Winter essence?

How much more "me" could I be?

This was, I realized, a way to be present. When I bring my natural energy and essence forward in each moment as an expression of my divine self, I am fully *here*. I am not in the past or the future. I am not projecting myself into some manufactured image or ideal. I am simply being who I am in the here and now, without compromise or apology.

When viewed through this lens, dressing your essence is a revolutionary act. By presenting yourself as the divine work of art you truly are, you are peeling away layers of conditioning, repression, and limitation. You are declaring, without a single word, "I am beautiful, and I am enough."

THE FOUR PILLARS OF SPIRITUAL DRESSING ARE:

- *Pillar #1:* See the loving essence in yourself and others
- *Pillar #2:* Engage heart-centered listening
- *Pillar #3:* Recognize your power to choose
- *Pillar #4:* Practice self-forgiveness

Of the many spiritual principles I learned at USM, I realized that all of them made me a better version of myself, and four of them are the foundation for dressing your essence. These guideposts elevate dressing from a purely physical art form to an embodied practice of transformation.

PILLAR #1: SEE THE LOVING ESSENCE IN YOURSELF AND OTHERS

One of the most powerful practices we can undertake is to learn to see the perfect, loving essence in ourselves and those around us.

We are unique works of art. Our bodies are our souls made manifest in living color, shape, texture, and contrast. When we stop seeing ourselves and others as broken, imperfect humans to be "fixed" or improved, we open the door to witness our own inherent beauty.

When you dress your essence, you will begin to see yourself in new ways. Instead of berating yourself, you may find yourself thinking different, more loving thoughts when you look in the mirror. Instead of digging through your closet thinking, "I have nothing to wear," you may find yourself feeling excited to choose the colors, patterns, and shapes that most fully represent your intentions each day. Instead of feeling invisible in a crowded room, you may start to notice all the ways you're making an impact.

In other words, the practice of dressing your essence will empower you to move through the world with greater love.

We cannot do this for others without first doing it for ourselves. Until we stop judging, belittling, and otherwise minimizing our own beauty, we will not be able to fully see, witness, and celebrate the beauty in others.

PILLAR #2: ENGAGE HEART-CENTERED LISTENING

While studying with Dr. Mary, I began to notice that I was developing more compassion for the conversations I had with myself. I realized that there was a "tape" running in my mind, a prerecorded conversation about who I was and what my life was worth in the world. As is the case for most people, this tape was predominantly negative.

I realized that this tape might never shut off completely, but I had a choice as to how I wanted to be with it. Could I treat the voice in my head with more compassion and less judgment? Could I love myself more instead of criticizing?

Heart-centered listening allowed me to discern where I was seeing and elevating my loving essence, and where I was squashing it. It changed how I live with myself.

When I learned how to listen and respond to my own inner narrative with greater love, I gained the ability to do the same for others. This changed how I converse with friends and clients, and how I lead my group programs. For example, I did an exercise with Dr. Mary where we picked a person we admired and wrote down all the qualities we liked about them. I chose my mother. As I've shared, she was a Spring essence and very different from me, and for a long time I believed we had little in common. However, during this exercise, we took the admirable qualities we listed about our chosen "other" and turned them back on ourselves. I saw that many of the things I loved about my mother were also

alive in me, just expressed in different ways. That was a profound healing moment—one I was able to receive because I was listening to myself with an open heart.

I am so grateful to be alive, and to be a woman who has wisdom to offer. When I listen with my heart, I can offer that wisdom in ways that create real impact for those in my circle. I know when to speak, and when to be silent. I know how I want to live with myself, and that invitation I am making to others.

PILLAR #3: RECOGNIZE YOUR POWER TO CHOOSE

None of us have life figured out. Many things happen to us, around us, and through us, not all of them happy or pleasant. And while we can't always choose the events we live through, we can always choose how we will engage with them.

This truth applies to all areas of life, from relationships, to work, to health, to spirituality, and it can be quite profound when we embrace it fully. But where I've found this Pillar to be most powerful is in the small, daily moments. In every conversation and interaction with ourselves or others, we can choose to see the loving essence and listen with our hearts—or not.

As a woman, this is particularly important for me. I am going to get older. I may gain weight. I will get wrinkles. I will change. This is inevitable. Yet, I have a choice about how I will be with that change. The spiritual part of me is ageless, and when I live from that place in myself and dress to adorn and elevate it, I will always feel youthful and vibrant.

If I want to fully express myself as a spiritual being having a human experience on Planet Earth, it is not only my right but my sacred responsibility to bring my essence forward in a way that creates the biggest impact possible. I am a gift from God to this world. You are a gift from God to this world. When we recognize this, and take the responsibility inherent in being and living as such a gift, we can stop making choices that get in the way of our individuality.

You are not here to meet some immobile, unattainable standard of beauty or perfection. That kind of beauty is stagnant. It's not alive. It doesn't move forward. Nothing in nature is identical; every flower, tree, animal, and stone is unique. Yet, it is all beautiful and perfect.

So, as you practice the art of dressing your essence, take full responsibility for the choices you make every day, big and small—for the language you use about yourself and others, for the ways in which you choose to shine or dim your inner light, for the rules you choose to follow or break. Free yourself from your limited interpretations of reality, humanity, and beauty, and watch what unfolds.

PILLAR #4: PRACTICE SELF-FORGIVENESS

When I hold events, I will sometimes ask the group to form a circle and observe each other. Sometimes, I'll ask the group to react to seeing a person in their unique palette colors, shapes, textures, and level of contrast. This helps us all understand what it feels like to be fully seen, and to see one another.

Other times, I'll ask the person front and center how it feels to be witnessed in their unique colors and design elements. For example, I'll dress them in their Power Color,

and ask, "How do you feel in this outfit?" They might say, "I feel invincible!" or, "I feel uncomfortable. I feel like I'm 'too much,' and like you're all judging me."

Then, I'll ask the group to share how they feel as they observe that person. Some might say, "I feel inspired by her! Look how strong and confident she is!" Others might say, "I feel like I'm not being in my own power. I feel jealous that she looks so strong, and I don't think I can feel that way."

The purpose of these exercises is not to call anyone out, make anyone wrong, or even to change anyone's mind. It's to bring forward an opportunity for self-forgiveness.

Can you forgive yourself for not claiming the true power of your essence? Can you forgive yourself for feeling insecure, jealous, or "not enough"?

USM provided keen insights into the importance of forgiveness. I needed to forgive myself for many misinterpretations and misunderstandings:

- Buying into unrealistic standards of perfection
- Thinking I had to dress a certain way in order to be accepted
- Believing that I needed to be less expressive in order to harmonize with my family when being more expressive was authentic
- Not recognizing how important healing the human "story of not-enoughness" is to dressing our essence
- Not embracing and claiming my own freedom sooner

Self-forgiveness disbands the pressure and dissolves the stress of judgments and pervasive unrealistic standards. All of us do the best we can with what we know at the time. Now we know something new: when we stop looking backward, forgive ourselves for past choices, and come fully into the present, we can embody our essence, and be the gift from God we were designed to be.

"

You can have anything you want in life
as long as you dress for it.

~ Edith Head

Dress Your Essence Every Day

You now have in place all the fundamentals of dressing your essence—your Seasonal profile, your unique palette colors, the psychology of color, the seven principles of design, and the four Spiritual Principles of Dressing to guide your daily choices. When you put them all together, you will have a blueprint for creating yourself as an inspiring divine work daily.

You deserve to dress your best no matter where you are or what you are doing. The more you present yourself as you, rather than a stylized image of you, the more gracefully you will move through life with ease and joy. Your creativity and confidence will blossom. Your interactions with both friends and strangers will transform. Your opportunities for success and growth will expand.

In this chapter, I'll show you how to apply everything you've learned in this book so that you never again need to stand in front of your closet and wonder,

"What should I wear?"

Additionally, I'll show you how to take your palette and design elements beyond your wardrobe and into all areas of your home, so you can be supported by your environment as well as by your clothing.

Putting It All Together

In this section, we'll further explore the differences between the energies of the Seasons when it comes to style. These determine how to create simple outfits by applying colors and design elements according to the Seasonal essence. This is not intended to be a strict rulebook for dressing, but rather a collection of ideas you can use as starting points for creating your own unique outfit combinations. I'll provide a list of "must-haves" for each Seasonal essence so you'll know where to focus your initial shopping efforts.

Spring

Spring is sunshine: fun, lighthearted, and a bit irreverent. Springs like to be comfortable and move freely in their clothing. They also do well when they incorporate a bit of irony and playfulness into their outfits: for example, wearing a sequined dress with motorcycle boots or a graphic tee with a satin ballgown skirt. Many Spring men like to add flair to their business suits by pairing them with bright boots or sneakers and whimsical ties.

MUST-HAVES

- *Fun footwear*: cowboy boots, print shoes, statement sneakers, bright boots
- *Graphic tees* in your palette colors
- *Jeans* in various colors, washes, and styles
- *Denim jacket*s ranging from casual to formal

SPRING OUTFIT IDEAS

- *Casual:* Jeans with tennis shoes in your hair color, a graphic tee in any of your palette colors, and a trench coat in your hair color. Add a fun scarf or bandana and a print tote to accessorize.
- *Semiformal/Business:* Dress pants in navy or another neutral; a top in the same neutral or your Romantic Red, your skin tone, or your ivory/wheat tone; and shoes in your hair color. Or, a print dress in your unique print and palette colors with bright espadrilles and a denim jacket. Add animated color throughout with a bright silk scarf, fun sunglasses, red coral jewelry (or jewelry in your metallic), and a statement handbag.
- *Formal:* A dress, jumpsuit, or suit in your Power Color or Supplemental Power Color; shoes and a matching handbag in your hair color or metallic; jewelry in your metallic; and a leather or suede jacket in your hair color. The key to formal dressing for Spring essences is to mix and match levels of formality to avoid looking and feeling "stuffy."

Summer

Summer is twilight, romance, and ease. Dressing for the Summer essence is all about flow. Why wear a T-shirt when you can wear a beautiful blouse? When refining your wardrobe and adding new items, you should look for refined details that make each piece special—like unique tucking or seaming, fine lace, cascading ruffles, and anything that adds formality and softness.

MUST-HAVES

- *Dark jeans* without holes or "distressing"
- *Longer jackets and sweaters*, particularly flowing dusters
- *Beautiful scarves, shawls, and wraps* in flowing prints (feathers, flowers, and leaves)
- *A softly-draped dress or skirt* in jersey knit, soft silk, or other fabric that exudes femininity
- *A wool cloth coat* in your neutral (navy, gray, or brown) or in a palette color
- *Comfortable yet elevated shoes* like flats or loafers in suede or soft leather, with handbags to match

SUMMER OUTFIT IDEAS

- *Casual:* Dark jeans with a flowing blouse or shirt in your skin tone, a long duster, and ballet flats in your hair color. Pair with simple jewelry in your metallic. Add a wide-brimmed straw hat and a matching tote for effortless feminine elegance.
- *Semiformal/Business:* A two-piece knit outfit (pants or skirt with a top) in one of your neutrals, an elevated scarf or shawl; and elegant boots or shoes in your hair color or metallic. Or, a long chiffon print dress, a cashmere cardigan, and a handbag and sandals in your hair color.
- *Formal:* A fluid dress in a longer length (below the knee) with lots of detailing like lace or embroidery. For Summer essences, it's important that the fabrics are formal, even if the shapes are less so. Coordinate your shoes and handbags in your metallics. Summer men can wear formal three-piece suiting in lightweight, luxurious fabrics with accents of their hair color and metals in details like cuff links, shoes, and pocket squares.

Autumn

Autumn essences need strong visual weight and texture. Even when you wear black, you're wearing textured black. Outfits for Autumn come together by mixing fabrics of various textures and complexities with prints and metals.

MUST-HAVES

- *Pieces with movement:* fringed jackets, scarves with feathers or fur
- *Suede or distressed leather:* leggings, jackets, shirts, skirts, and belts
- *Animal prints* in your colors
- *Wood jewelry* or tortoiseshell-inspired jewelry
- *Comfortable knits with movement*
- *Tooled, studded, or embellished leather* boots, belts, or other accessories

AUTUMN OUTFIT IDEAS

- *Casual:* Suede leggings in your neutral tucked into leather boots, a knit top in rust or another palette color, a textured jacket or blazer, an animal print scarf, and chunky wood jewelry. Or, dark jeans, a T-shirt in any palette color, a tweed or suede jacket, heeled boots in your hair color, and layered necklaces in your metallics.
- *Semiformal/Business:* A knit top over a suede fringed skirt; a vest in a heavier, textured fabric; a velvet jacket; all paired with interesting belts, necklaces, and a complementary scarf. Or, choose a printed knit dress or two-piece set in a longer length with movement, paired with a tooled leather belt, a heavy moto jacket in your hair color, and heeled boots.
- *Formal:* Autumn essences do well wearing their metallics for formal occasions—for example, a bronze or copper knit dress in an asymmetrical cut (i.e., shirred on one side or with an uneven hemline) paired with chocolate diamonds, a fur (or faux fur) stole, and shoes in your hair color. Or, wear a velvet dress, jumpsuit, or suit in your Power Color paired with a metallic dress boot, copious accessories, and a fabulous scarf.

Winter

As you'll recall from our introduction to the Winter essence, as a Winter you are either the hero or the villain, so drama is essential. Winter also tends to be more formal than any other Season, so even your casual clothes will incorporate some element of elegance and glamour.

MUST-HAVES

- *A dramatic black leather jacket* with hardware in your metallic
- *Abstract prints* in your palette colors
- *Black and/or dark blue jeans*
- *Pieces that play with volume and scale:* for example, oversized white shirts with interesting structural collars
- *Anything black and white,* including shoes

WINTER OUTFIT IDEAS

- *Casual:* Wear dark navy or black jeans with studded black moto boots, a black T-shirt, and an ethnic print jacket in your palette colors. The opposite is to wear white jeans or jeans in an icy pastel with a lighter shirt and high-contrast accessories. Or wear luxe jogger pants with a clean white T-shirt, leather sneakers, and a black leather moto jacket.
- *Semiformal/Business:* Tuxedo pants, a white button-up shirt or blouse, and a velvet blazer paired with white tennis shoes or metallic heels, with dramatic accessories in your metals. Or, black leather leggings, an oversized top in your palette colors with a dramatic silhouette, and over-the-knee boots.
- *Formal:* For Winter, formality plays out in silhouettes. All-black dressing with contrasting accessories (crystal, silver, antique brass, bronze, or copper), jet-black accessories with lighter-hued garments, and bold metals with heavy visual weight lend elegance. You could also wear a dress or suit in your Power Color with a patent leather trench, a belt and jewelry in your metallics, and a fur collar or stole over it all.

Photos: Michael Hedley

The Simplest Outfit for All Seasons

When I'm coaching my clients to pack for a trip, we talk about the simplest formula for constructing a stunning outfit. This formula can be used by anyone, no matter their age, Seasonal essence, or climate.

THE FOOLPROOF FORMULA FOR DRESSING YOUR ESSENCE

- *Wear a column of color.* Choose a bottom and top in the same color. Neutrals are easiest, but you can choose any color from your palette.
- *Choose shoes, a handbag, jewelry, and other accessories in your hair color or your metallic.*
- *Top it with a colorful scarf and/or jacket.* Add a pop of color with a scarf, or wear a jacket in any accent color.

Here are some examples of how this can be adapted for each Season:

- *Spring:* A column of navy blue with shoes and a handbag in their hair color, gold jewelry, a coral scarf, and a camel trench coat.
- *Summer:* A column of eggplant with shoes and a handbag in their hair color, pewter jewelry, and a duster or kimono in a subtle print.
- *Autumn:* A column of rust or olive with brown shoes and handbag, layered copper jewelry, an olive tweed jacket, and an animal print scarf.
- *Winter:* A column of black with bright silver jewelry; black patent shoes, leather or tapestry boots, or any shoe with dramatic silver accents; a silver trench coat; and a colorful scarf in an abstract print.

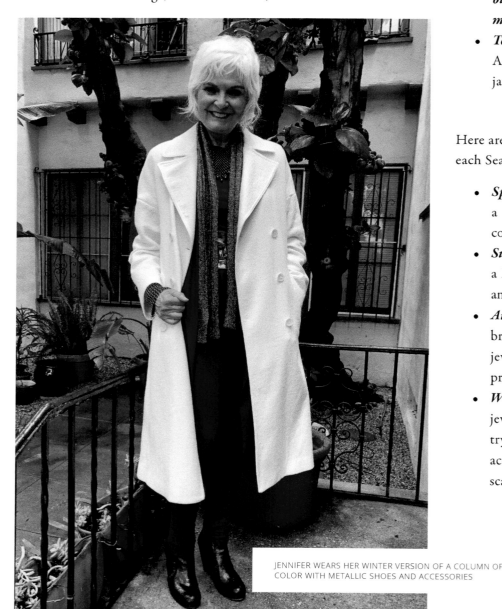

JENNIFER WEARS HER WINTER VERSION OF A COLUMN OF COLOR WITH METALLIC SHOES AND ACCESSORIES

Bringing it Home

Once you've begun to integrate the concepts in this book into your wardrobe, you will notice an immediate shift in your relationship to color and form. Soon, you'll start to notice how the spaces you enter and occupy every day impact your energy. Where do you feel most like yourself? Where do you feel drained? Where do you feel anxious or overwhelmed? And how do those spaces relate to your unique palette, shapes, texture, complexity, and scale?

Too many people design their home the way they design their wardrobe: with an eye for how it looks and what image it projects. This will almost always result in a space that feels less than comfortable. When designing your home, follow all the principles of design you've learned in this book. The shapes and patterns present in your furniture, art, and accessories should reflect your own sacred geometry. Your walls, furnishings, and accessories should reflect the colors and levels of contrast in your palette. The wood tones in your décor should match your hair color, and the metals in your light fixtures, bath fixtures, and even doorknobs should be those from your palette.

When I support my clients to redesign their interior spaces according to their essence, I never ask them, "How do you want this room to look?" Instead, I ask, "How do you want to feel in this room?" The first question brings them outside themselves. The second invites them to land within themselves.

In a moment, I will give you some tips on how to choose colors and accessories room by room, but first let's look at interior design from a Seasonal perspective.

SPRING HOMES

Spring essences, in general, like their homes to be fun, animated, and colorful. They like a lot of natural light, as a sense of feeling uplifted and energized is important. They like entertaining groups of friends and family, and therefore like their spaces to feel casual and inviting.

SUMMER HOMES

Summer dwellings are all about relaxation. Summer essences like to be the Lady or Lord of the Manor, and of all the Seasonal essences are most connected to the idea of "having a home" rather than having a "place to live." They love muted, tone-on-tone colors and décor, and often focus on how one room can flow seamlessly into the next.

AUTUMN HOMES

Autumn homes are focused on texture and complexity. Warm wood tones are vital. Tile, rugs, and furniture should all be highly textured, rugged, and substantial. For an Autumn, their home is their kingdom/queendom, so warm, welcoming energy and a sense of generosity is important. Autumns exude firelight energy, so they should also have some sort of fire feature—like a fireplace, wood stove, or outdoor firepit—as a focal point of their space.

WINTER HOMES

Winters love black and white and/or neutral décor (although there are exceptions to this). Winters strive to cultivate a sense of quiet stillness in their space. Graphics, prints, and shapes tend toward the abstract—think Art Deco styles, moonscapes, and marble. For a Winter, their home is their sanctuary; they may create a formal space for receiving guests while keeping other parts of the home private for their own use.

Designing Your Home Room by Room

BEDROOM

For bedrooms, paint the walls in your skin tone or a value of your Romantic Red. Choose a bedspread in your Romantic Red, eye color, or Support Color, and build the rest of your décor from there. Wood tones should match your hair color; if you have more complexity in your hair color, you can use a mix of wood tones to represent that. Overall, the level of contrast should represent what is appropriate for you personally.

The bedroom is the domain of the feminine. When a couple shares a bedroom, it should be designed using the palette and shapes of the woman. For same-sex couples, draw from the palette of the partner whose energy tends to be more feminine. This will have the effect of creating a more soothing and nurturing space for sleep and deep rest.

FAMILY ROOM/LIVING ROOM

Choose a variation of your skin tone for the family room. If you have a mix of skin tones in your family, choose one person's skin tone for the walls and bring in others' skin tones in the fabrics and furnishings. This will help everyone be fully seen and at ease in this space.

Wood tones in the family room should reflect family members' hair colors, so a mix of wood tones is often appropriate. For example, one of my clients has lighter brown hair, while her husband's hair is almost black. Their coffee table and end tables are in her hair color, while the beams on the ceiling and the bookcases are in his.

When choosing décor, start with the couch(es) and build outward from there. Neutrals are always safe choices, but your eye color, Romantic Red, Support Color, or even your Power Color are also great choices. Accents can be in any color(s) from your palette. Again, if you're living with a partner and/or children, find common ground and bring in some variation of everyone's tones using pillows, rugs, and artwork. There will almost always be areas of crossover between the palettes of family members, so find those commonalities and work with them.

A SPRING BEDROOM

A SUMMER LIVING AREA

be those in your palette, particularly if you've chosen a glass and metal desk.

DINING ROOM

The dining room is one place where you can really bring the drama. Fabric upholstery, curtains, dishes, decorative plates, and glassware are great places to bring in your Power Color, Supplementary Power Color, accent colors, and metallics. Mix metals for an eclectic feeling, and choose artwork that represents your sense of adventure or highest personal values. Since the dining room is a great place for discussion and entertaining, you'll want to highlight your interests, hobbies, travels, and personal tastes.

In cases where one partner has a high level of contrast, complexity, or texture and one partner has low to medium contrast, complexity, and texture, accent pillows can be a lifesaver. You can bring one partner's palette into the scheme with pillows without overpowering the other person's energy.

HOME OFFICE

Your Support Color or eye color is a great addition to your home office. Your Support Color will support whatever it is you're creating, while your eye color will create a sense of calm and balance. Varying the color value can help the space feel energizing, calm, or focused, depending on your needs. Again, your wood tones should complement your hair color, and your metals should

AN AUTUMN KITCHEN/DINING AREA

MORE HOME DESIGN TIPS

When bringing your palette colors and unique essence into your home, start with one room at a time. Otherwise, it's easy to get overwhelmed and lose the "feeling" you want to create in each room.

If you're having trouble choosing which of your palette colors to incorporate into your design, go back to the question, "How do you want to feel in this room?" Do you want to feel energized, vibrant, and in charge? Bring in your Power Color! Do you want to feel balanced? Use your eye color. Do you want to feel romantic and sensual? Choose your Romantic Red. Do you want to feel a range of all these things depending on your mood? Start with your neutrals and add easily changeable accessories like throw pillows, candle sticks, vases, or flowers so you can easily match the energy of the moment.

While there are many rules and conventions of design that I could share here, in the end, it all comes down to this: Do you feel completely *yourself* in your space? Do you feel confident, beautiful, relaxed, and supported? If so, you're doing it right, regardless of what your space looks like to others.

AN AUTUMN LIVING ROOM

A WINTER LIVING ROOM

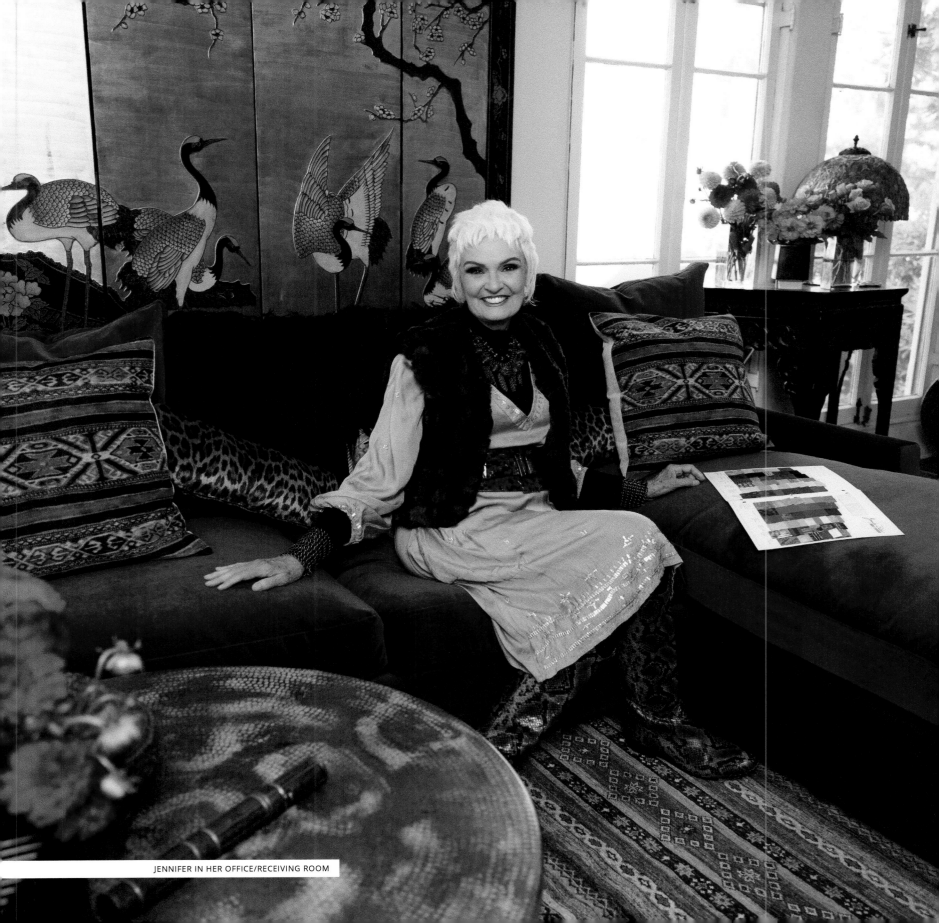

JENNIFER IN HER OFFICE/RECEIVING ROOM

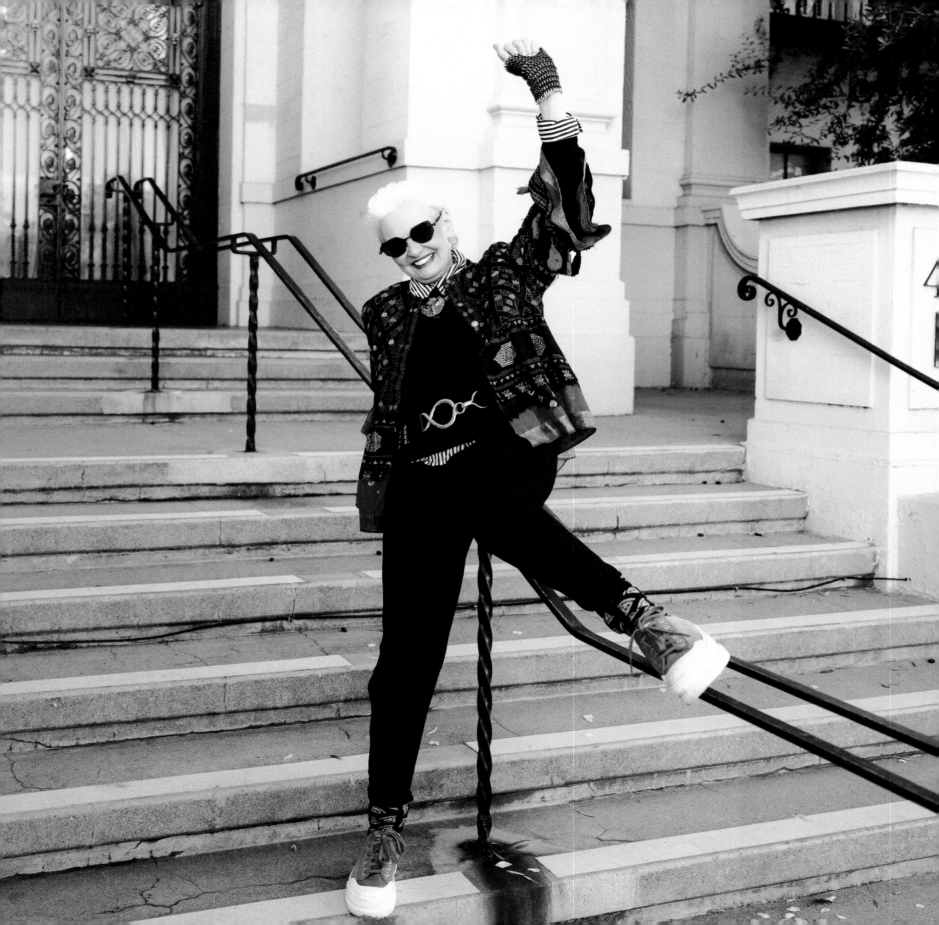

Afterword

Thank you for taking time to read *Dress Your Essence.*

I see this book as a major part of my legacy, the culmination of my life's work. Not wanting to leave this planet with my music still in me, I've shared as much as I can in the hope that the magic and beauty of dressing your essence will live on for many generations.

My primary reason for writing this book was to provide an alternative point of view to an image-based fashion industry. Fashion should exist to serve our self-expression, not mask our genuine expression. When we look first in the mirror and recognize the work of art that we were born to be, we can dress as a celebration of who we really are!

I appreciate that you invested the time to learn more about your beautiful self. Hopefully something you read resonates with your heart, and has empowered you in at least some small way to move forward on your own path to true beauty.

Love,

Jennifer

Stay in Touch

.

🌐 jenniferbutlercolor.com

✈ jennifer@jenniferbutlercolor.com

f @JenniferButlerColor

in @jennifer-butler-a74209a

▶ @jbcolor

Resources

Find Your True Colors

Your purchase of this book includes a number of free resources.
You can access them at **learn.jenniferbutlercolor.com/dressyouressence**

Get your Personal Color DNA Palette + Personal Design, book a VIP session, take one of our online courses, or study Jennifer's online materials at **jenniferbutlercolor.com**.

Want to book Jennifer to speak? Email **jennifer@jenniferbutlercolor.com** for more information.

CONTRIBUTORS AND OTHER RESOURCES

Siddiqi Ray Photography

You'll notice many beautiful "true essence" pictures of me in this book. Siddiqi Ray and her camera have summoned the true essence of such diverse subjects as Nelson Mandela, the Dalai Lama, the Buddhist nuns of Tibet, the Kennedy family, the Navy SEALs and the staff at the Mayo Clinic. Her portraits have in *Time*, *USA Today*, *Allure*, *South Cape Times*, and on her mother and grandmother's coffee tables! She is the creator of the Soul Portrait. I'm honored to include her images in this book. **siddiqiray.com**

Mikel Healey

Your perceptive before and after photos have been inspiring our clients for nearly a decade—a testament to the fact that true beauty never goes out of fashion. **mikelhealeyphoto.com**

Maria Rangel

Thank you for the gorgeous photographs for my first book, *The 7 Principles of Design*, as well as for your contributions to this book. Your grace and talent still resonate. **lunamariaphotography.com**

Emily Keough

Emily, your makeup mastery is extraordinary. I'm grateful to have found you amongst all the Los Angeles resources. Thank you. **emilykeough.com**

Donna Marberger

Donna, your "layering lifestyle" clothing has provided the column of color for hundreds of our clients. Thank you for your willingness to step away from the industry norms of black, white, and gray, to embrace wearer-friendly colors that inspire a more authentic communication. What would we do without your skin tones? **bydonnam.com**

Andrea Serrahn

At different times, we both experienced the magic and beauty of Indian textiles. How amazing that my clients and I found your exceptional designs and wonderful Asian fabrics in your Oakland boutiqe. Truly, you empower our creativity and femininity. **serrahna.com**

Edison Ortega

Thank you for making such beautiful clothing, scarves, and handbags available to our community. **thehouseshowroom.com**

Greta Lovina

Thank you for making so many of the absolutely beautiful clothes I'm wearing in these photos! Your eco-fashion aesthetic, gift for upcycling fabrics, and willingness to custom-dye to suit the Seasons are exceptional. I'm so glad we found each other. **lovinadesigns.com**

Danski Blue

Your creative clothing boutique in Ojai, California is one of my favorite shopping destinations. I love everything I've found in your store—especially my saffron gold hooded coat! **@danskiblue** (Instagram)

Suzi Click

Your gift for taking vintage and Asian fabrics and combining them in entirely new creations is exceptional. **suziclick.com**

Jasmine Knauer

You created the amazing Cordelia clothing line, which adorned many of my clients in the 2000-2010s. Although the line is retired, we continue to celebrate you as we wear pieces that we still own. On a personal note, you are the angel that guided me to USM. Thank you!

Nienke, Katherine Moffat, and Tish Pollack

You are the most amazing jewelry designers! Your commitment to creating accessories in the right visual weights and color harmonies for each Season has made it possible to find lovely adornments that work for everyone. Thank you for your fearless commitment to designing for the Seasons, not the fads. **@nienkejewelry** (Instagram), **katherinemoffat.com, divabeads.biz**

BACKGROUND ON OUR BEFORE AND AFTER MODELS

- *J.J. Cheng* (Spring) is a leader in the Latin music industry, named *Billboard*'s "Latin Power Player," "Most Influential Woman in Music Rights" honoree and a global leader in the performance and digital rights arenas.
- *Sophie Fletcher, PhD* (Summer) is an expert in bodywork modalities, helping clients by applying Somatic Experience, breathwork, energetic clearing techniques, Human Design, and subtle energetic practices that help to "reboot" human health.
- *Lynn Greenbaum* (Autumn) is a New York-based stand up comedian.
- *Christopher Maher* (Winter), a former Navy SEAL, is the founder of True Body Intelligence, an innovative path to health, wellness, and longevity. He is the author of *Free For Life*, as well as an inventor, entrepreneur, speaker, and coach.

Photo Credits

- Page 75:
 - Spring photo: Katherine Moffat Jewelry
 - Summer photo: Katherine Moffat Jewelry
 - Autumn photo: Katherine Moffat Jewelry
 - Winter photo (Jennifer): Mikel Healy
- Page 77: Amir Magal

CHAPTER 6

- Page 81:
 - High Contrast: Jonathan Borba via Unsplash
 - Medium Contrast: Olena Bohovyk via Unsplash
 - Low Contrast: Toa Heftiba via Unsplash
- Page 82:
 - Rakalaya before: Rakalaya's personal photo
 - Rakalaya after: Amir Magal
- Page 83:
 - High Contrast (Jennifer): Wesley Forsyth
 - Medium Contrast: Mikel Healey
 - Low Contrast: Mikel Healey
- Page 86:
 - High/Rugged Texture: Robert Mayner via AdobeStock
 - Medium Texture: Alexis Chloe via Unsplash
 - Low/Smooth Texture: Nikhil Uttam via Unsplash
- Page 88: All photos by Siddiqi Ray
- Page 91: Face shapes adapted from an image by Bus109 via AdobeStock
- Page 92:
 - Eye shapes adapted from an image by cheremuha via AdobeStock
 - Brow shapes adapted from an image by WinWin via AdobeStock
- Page 93:
 - Nose shapes adapted from an image by julvil via AdobeStock
 - Mouth shapes adapted from an image by eveleen007 via AdobeStock
- Page 96: Siddiqi Ray
- Page 97:
 - High Contrast Print: Ксения Коваль via AdobeStock
 - Medium Contrast Print: Maria via AdobeStock
 - Low Contrast Print: Makayla via AdobeStock
- Page 98:
 - Large Scale Print — YauheniyaA via AdobeStock
 - Medium Scale Print — Five Million Stocks via AdobeStock
 - Small Scale Print — savvalinka via AdobeStock

- Page 99 (from left to right):
 - Jennifer in her skin tone: Mikel Healey
 - Jennifer in her Romantic Red: Mikel Healey
 - Jennifer in her Power Color and amber: Stacey Lievens

CHAPTER 7

- Page 105: Photo: Maria Rangel

CHAPTER 8

- Page 109 (clockwise from top left):
 - Mikel Healey
 - Mikel Healey
 - Mikel Healey
 - Татьяна Евдокимова via AdobeStock
- Page 111: All photos by Mikel Healey
- Page 113: All photos by Mikel Healey
- Page 115 (clockwise from top left):
 - Maria Rangel
 - Amir Magal
 - Mikel Healey
 - Mikel Healey
- Page 116: Jennifer Butler's team
- Page 118: Natalia via AdobeStock
- Page 119:
 - Summer dining room: Nairobi via AdobeStock
 - Autumn kitchen: lenisecalleja via AdobeStock
- Page 120:
 - Autumn living space: Allan Wolf/Wirestock Creators via AdobeStock
 - Winter living room: Stockeye Studio via AdobeStock
- Page 121: Siddiqi Ray

BACK MATTER

- Page 122: Siddiqi Ray
- Page 134: Siddiqi Ray

Acknowledgments

I would like to thank the following people for their contributions to this book.

Thank you to my publisher, Bryna Haynes of WorldChangers Media. You've been with me every step of the way, guiding the outline and contents of this book, the cover design, layout, publication, distribution and so much more. And, you also said "yes" to your colors. Thank you for stepping into a Technicolor life!

Thanks to Marci Shimoff, the brilliant author of *Happy for No Reason*, for founding the Miracles Group, and enabling me to create space to author this book.

Thank you to my amazing Miracles Inner Circle business and personal coach, Ginny Neal, for supporting my vision and for introducing me to Bryna.

Thank you also to Jasmine and Shelly for cocreating with me in our Miracles Group. Truly, it took a village.

My Family

Thank you, Mom, for starting the Calico Cat in Hibbing, MN. Your fabric store created the foundation for my career, and the resources for our entire family (five brothers, and me) to have advanced education.

Dad, thank you for always believing in me, and sharing the color work with others. You were my first promoter and kickstarted my career. Truly, you were my Winter Hero.

My brothers, Bill, Brian, Bob, Burton and Bruce (how am I not named Bridget?), thank you for your constant love and support. You are the masculine energy that empowers my Divine Feminine.

My Teachers

Thank you to Werner Erhard, founder of EST training and the Forum. You provided my first exposure to the transformative power of personal growth, which has carried me through a lifetime of learning.

Wilson College (Chambersburg, PA): during my time there (1965–1969), Wilson was an all women's college that taught me the importance of sisterhood and allowed me the opportunity to start my boutique, which in turn, helped me to win the Glamour Top 10 College Girls competition. The Experiment for International Living also opened the door for me to travel to India where I experienced firsthand the incredible power of color as a soul-expression.

Suzanne Caygill, the originator of Color Harmony Theory. Your book *Color, the Essence of You* is the gold standard for truly understanding the power of color harmonies to authentically express your soul. I am eternally grateful for the privilege of having met you, studied with you, and been granted permission to carry your important principles forward for the next generation.

Reverend Michael Beckwith and Leigh Brown, your spiritual support has been invaluable.

Drs. Ron and Mary Hulnick, thank you for creating USM. The experience of living with the Spiritual Principles and applying them to beauty has amplified and empowered my life's work.

Penelope Jane Smith, my Financial Freedom coach, thank you for holding the vision for me to create a nine-month training program to ensure that the magic of Color Harmony lives on.

To the twenty-three ladies who said yes to my nine-month True Beauty Mastery Programs of 2023 and 2024, thank you for immersing yourselves in beauty as a spiritual practice, and for becoming the living embodiment of this work as examples for the generations to come.

My Dearest Friends:

Diana Syvertson, my friend for more than thirty-five years living life in our colors. Without you, there would have been no first book. Your friendship has meant more to me than you will ever know. I treasure you.

Nicole Becker, thank you for starting the first Women Empowered (WE) group and including me in it. That group was my foundational support for many years. You taught me how to create and empower my life's vision.

Brandee Sabella, thank you helping me birth the True Beauty Movement, and for holding the vision for an ever-widening circle of empowered, beautiful humans owning their sovereignty and dressing their full essence.

To the Divine Diva Group: Diana, Tara, Jill, Nicole, Holly, Wendy Sue, Shivani Jane, I treasure our divine connection and the unconditional, unwavering love and support you have given me.

Shivani Jane Miller, thank you for your beautiful example of living authentically. You continue to facilitate meaningful relationships, even after departing this life.

To Mia Rue, you stepped forward into your Dahlia Autumn colors, and brought your family into the fold. Thank you for living this work.

My Staff, Past and Present

Teresa Dubois, your understanding of the psychology of color and the importance of showing up as ourselves laid the foundation for many of our very early client relationships. And you really embraced the concept of beauty as a healing art. Thank you.

Anu Fergoda, you worked by my side for so many years, helping me grow the company and write my first book, *Reinventing Your Style: 7 Strategies for Looking Dynamic, Powerful, and Inspiring*. You are off to new adventures, but never forgotten.

Leslie Harvey, you have been a godsend. Who knew that a Broadway dancer turned choreographer would become such an integral part of the Jennifer Butler Living Color enterprise. Your gentle, thoughtful guidance has supported many clients to fully embody their true beauty. And you keep the business running brilliantly! Thank you.

Kim Christensen, your tenure as a part-time, full-time, some-time staff member has run the gamut. Thank you for your brilliant writing and support in editing this book. You've embraced the notion of color and design as a healing art and have applied it wherever possible as you create Divine Order for clients of your organizing business. Thank you for being a true steward of the color work.

Roland Denis, you showed up at the right time, a handsome, hardworking college student willing to matriculate and manage two jobs in order to support our marketing efforts and technology needs. Thank you for your youthful energy and unwavering support.

And finallly, Carol Gallion, Bella Nudel, Dana Menkus-Tlumak, Linda Terry, Laura Dwan, Cheryl Planert, George and Karen Daisa, your willingness to stand in front of groups of strangers and model before and after outfits helped countless new friends experience *authentic beauty for the first time*.

About the Author

Jennifer Butler is the world's leading expert in the sociology of style and color. Her love and talent for fashion began in her mother's Hibbing, MN fabric store and expanded in college where demand for her exotic, imported clothing led her to open a small boutique called Piece of Mind. Her design work and entrepreneurship won her the honor of being named one of *Glamour* magazine's Top Ten College Girls of 1969. It also led to a feature article and photo in *Women's Wear Daily*.

Later, as a stylist at Vogue Patterns, Jennifer's thoughtful approach to fashion helped extend her color and design work internationally. This included a collaboration with color forecaster June Roche, corporate fashion director for Milliken, one of the country's largest textile manufacturers and dye mills. Together they created a color symposium that reached more than six thousand of the top designers in the automotive, interior, and fashion industries.

After moving to Los Angeles, Jennifer had the privilege of studying with leading color theorist, Suzanne Caygill, founder of the four-season color harmony theory. With her advanced understanding of the psychology of color and her fashion expertise she created Jennifer Butler Living Color, Inc., and founded the True Beauty Movement.

Over the course of her career, Jennifer has helped more than seven thousand clients—ranging from CEOs and business executives to celebrities, artists, and community leaders—to powerfully, authentically, and effectively express themselves.

Jennifer shares her individualized approach to color and fashion globally as a talented speaker and educator. She is the author of *Reinventing Your Style: 7 Strategies for Looking Dynamic, Powerful, and Inspiring*.

She earned her B.A. degree in sociology with an art history minor at Wilson College in Chambersburg, Pennsylvania, and studied spiritual psychology at University of Santa Monica.

Learn more and book your Color DNA Palette session at **jenniferbutlercolor.com**.

About the Publisher

Founded in 2021 by Bryna Haynes, WorldChangers Media is a boutique publishing company focused on "Ideas for Impact." We know that great books change lives, topple outdated paradigms, and build movements. Our commitment is to deliver superior-quality transformational nonfiction by, and for, the next generation of thought leaders.

Ready to write and publish your thought leadership book? Learn more at WorldChangers.Media.